Drawing Closer

THE PAINTINGS AND PERSONAL REFLECTIONS OF

Carolyn Blish

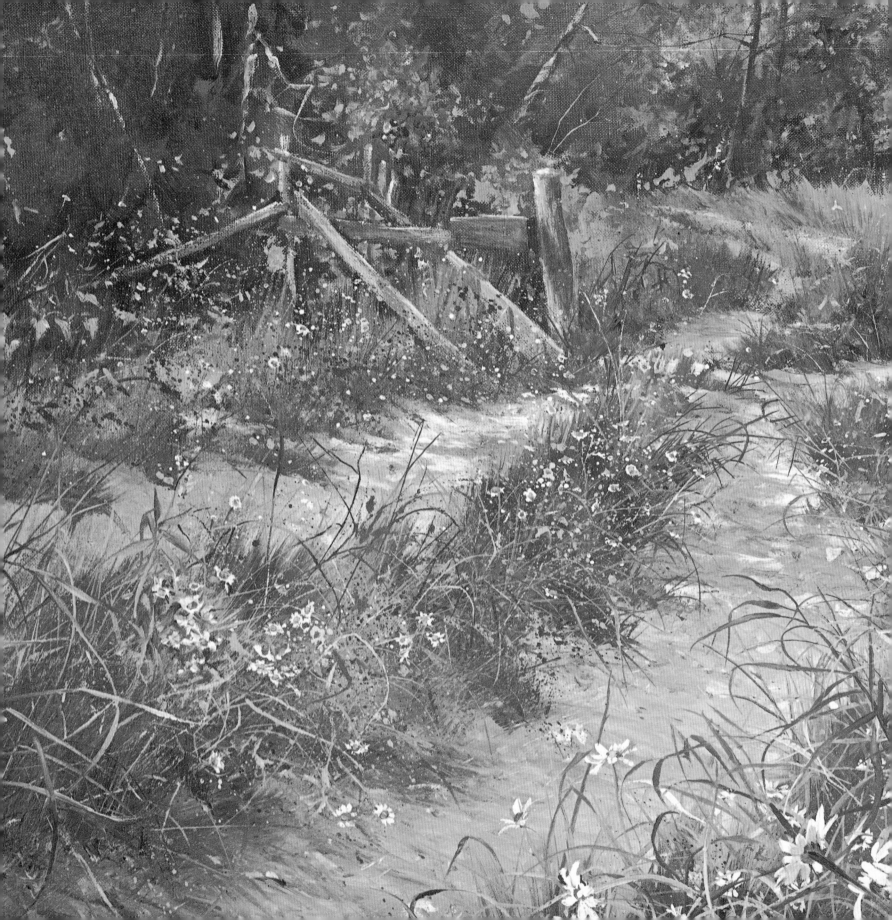

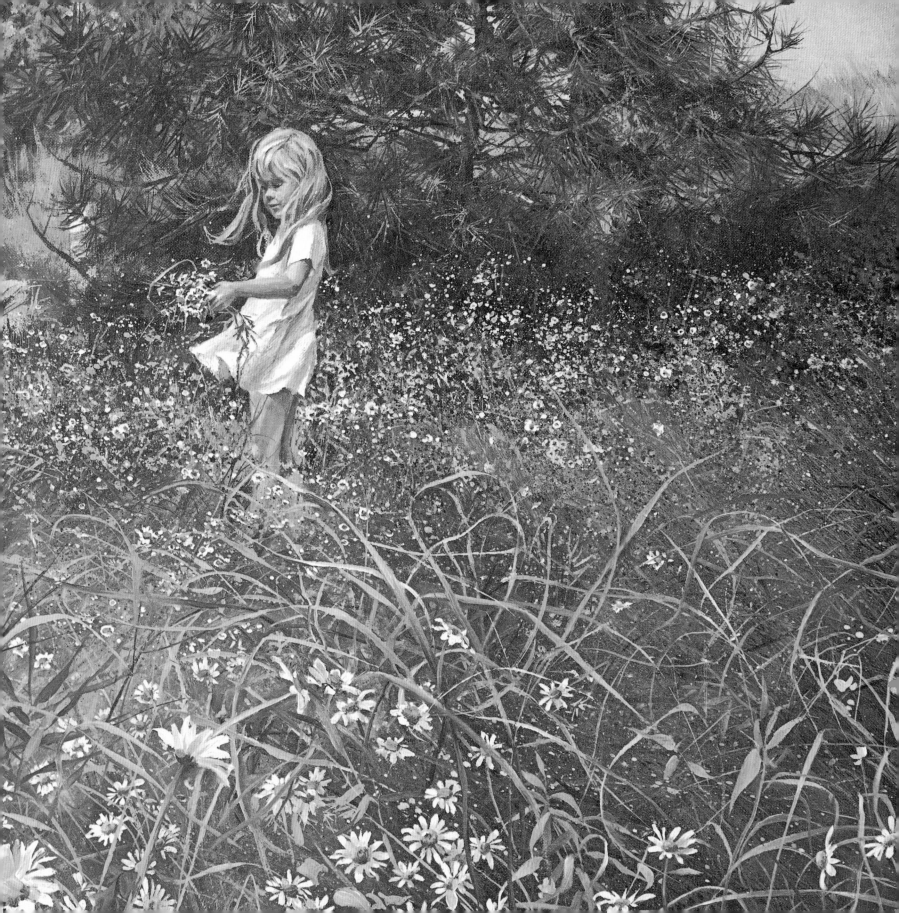

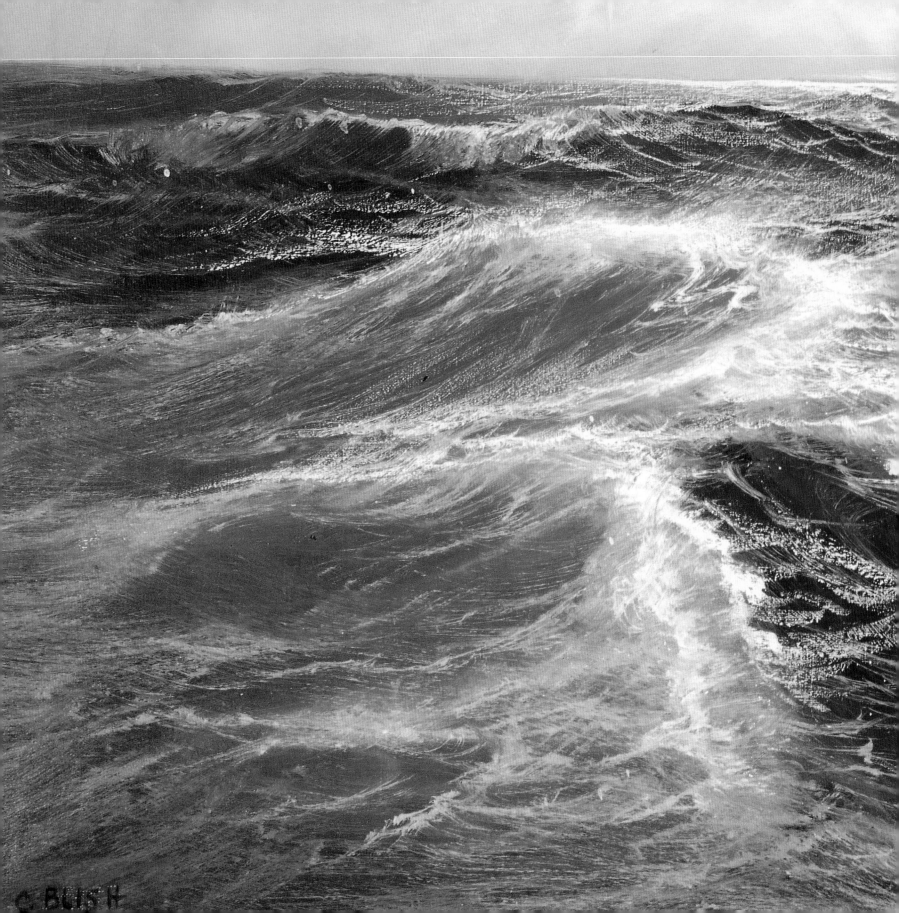

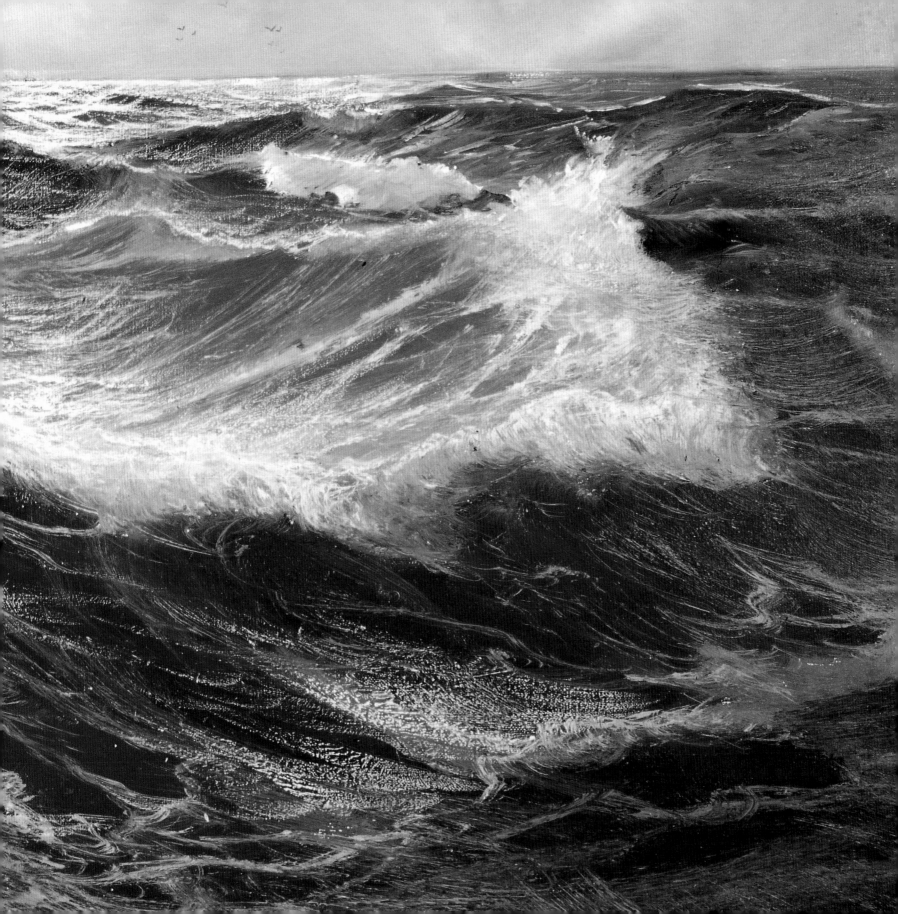

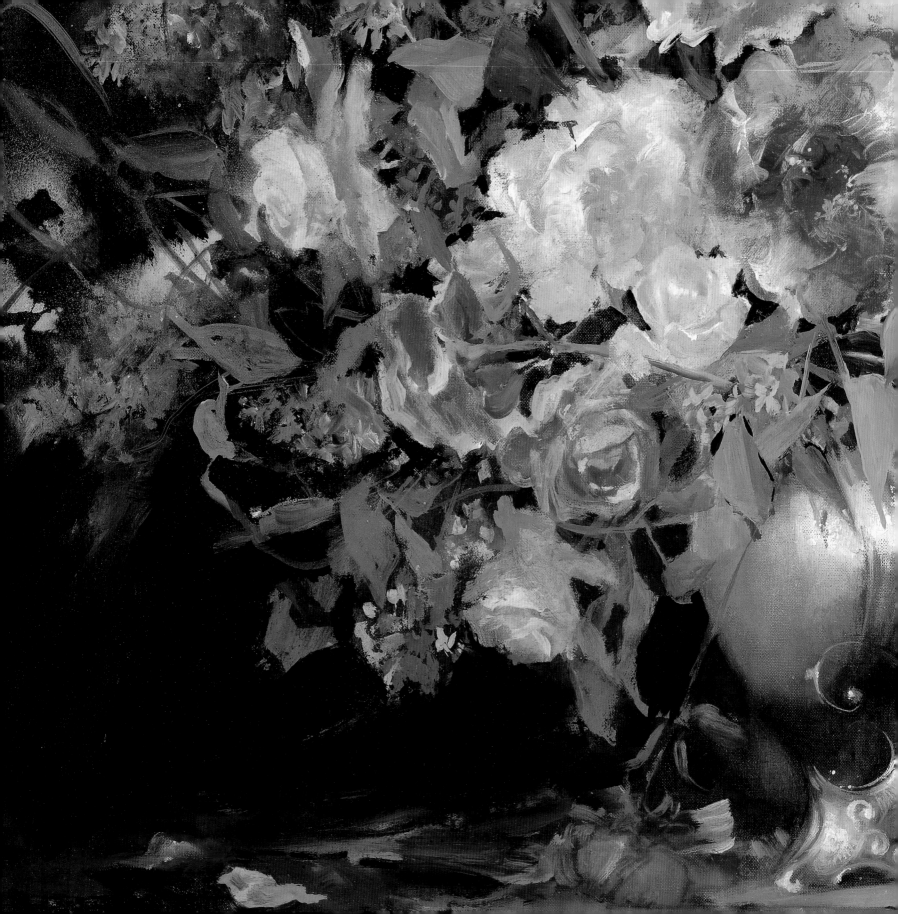

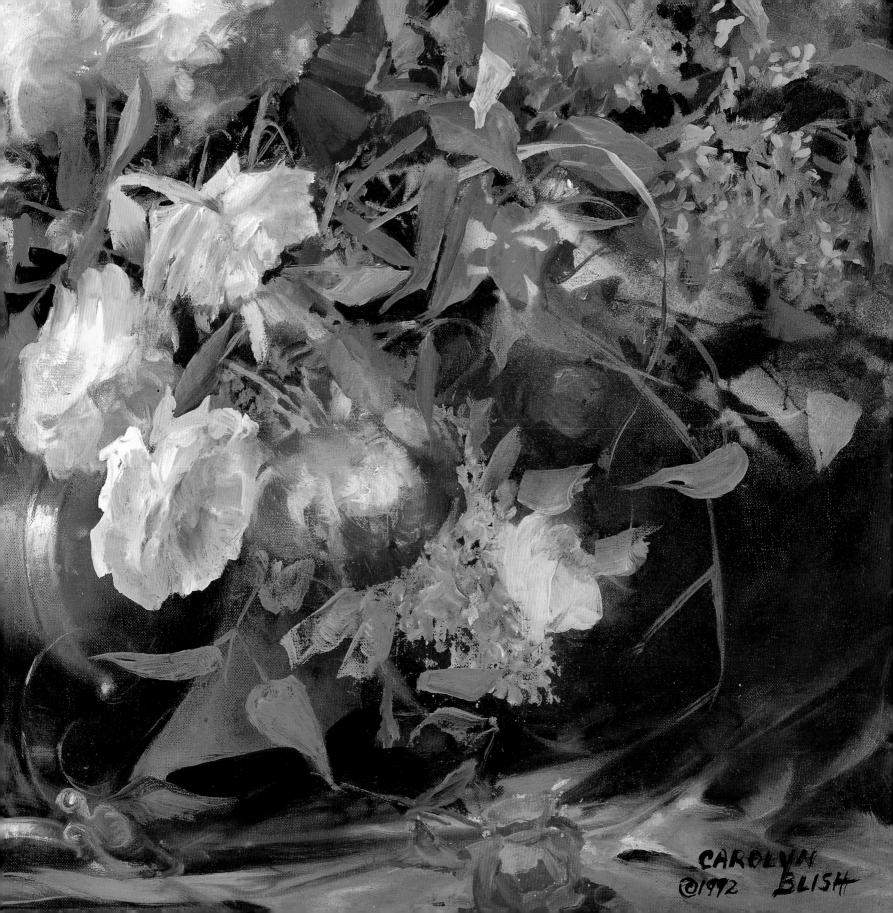

CAROLYN
©1992 BLISH

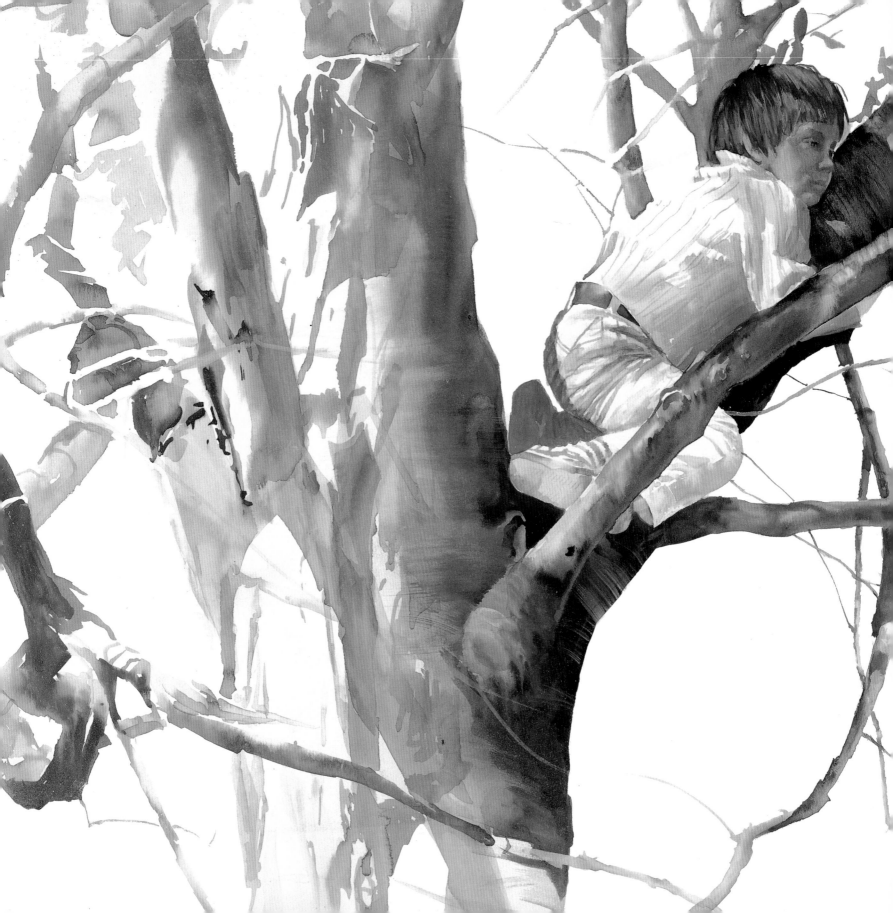

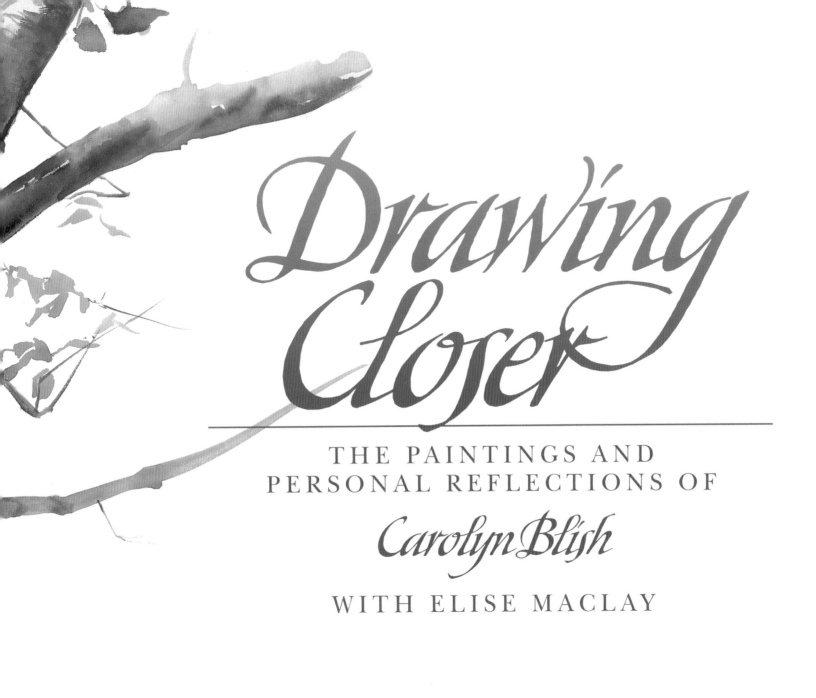

Drawing Closer

THE PAINTINGS AND
PERSONAL REFLECTIONS OF

Carolyn Blish

WITH ELISE MACLAY

THE GREENWICH WORKSHOP PRESS

This journey of Drawing Closer to God is dedicated,
with a heart of gratitude, to many people:
My children and grandchildren, whose winsomeness grace these pages.
Scott Usher, whose vision and leadership gave voice to this book.
Elise Maclay, who in her editing not only cultivated my garden, but, from her
own garden, so lovingly and generously sprinkled both flowers and butterflies.
Judy Turziano, whose heart for design brings joyful surprise with the turning of each page.
Christian friends whose prayers gave wings to this book.
My husband, Stan, the love of my life…who held the candle for this journey.

A GREENWICH WORKSHOP PRESS BOOK
Inquiries should be addressed to The Greenwich Workshop, Inc.,
One Greenwich Place, P.O. Box 875, Shelton, Connecticut 06484-0875.
For information about the art of Carolyn Blish, please write to The Greenwich Workshop, Inc.,
at the address above, or call 1-800-577-0666 (in the U.S.) to be directly connected with
the authorized Greenwich Workshop dealer nearest you.

•

Library of Congress Cataloging-in-Publication Data:
Blish, Carolyn, date. Drawing closer : the paintings and personal reflections
of Carolyn Blish / with Elise Maclay.
p. cm. ISBN 0-86713-041-5 (Hardcover : alk. paper)
1. Blish, Carolyn, date. —Themes, motives.
2. Blish, Carolyn, date. —Psychology. I. Maclay, Elise. II. Title.
ND237.B643A4 1997 759. 13—dc21
97–10708 CIP

•

ACKNOWLEDGMENTS
The author and publisher have made every effort to secure proper copyright information.
In the case of inadvertent error, they will be happy to correct it in the next printing.
The Greenwich Workshop extends grateful thanks for permission to reproduce the following:
pp. 73 quote from the lyric to *Color Outside The Lines,* ©1995 by Les Julian
and William Flowerree, published by Les Julian Music BMI.

•

Scripture in this book is quoted from the following sources:
The Living Bible, The King James Bible, The Revised Standard Version,
The New International Version and The New American Standard Bible.

•

FRONTIS ART
2–3 Detail from *Roadside Daisies*
4–5 Detail from *Restless Sea*
6–7 Detail from *Heaven Scent*

•

Introduction by Jill Briscoe
Book design by Judy Turziano and Peter Landa
Display typeface, *Blish,* by Philip Bouwsma
Manufactured in Singapore by Imago
First Printing 1997
97 98 99 0 9 8 7 6 5 4 3 2 1

Contents

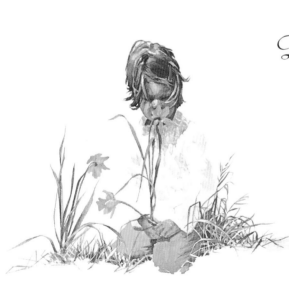

Introduction

When faith paints a picture, you know Carolyn Blish is holding the paint-brush. When trust mixes the colors, you can be sure Carolyn is at work. When hope needs dispensing, Carolyn sketches the shape of it, and when love needs expression, God taps a beautiful friend of his on the shoulder, and the joy of living is splashed all over a clean white page.

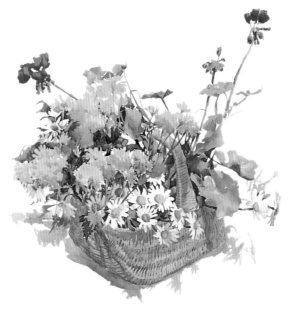

• • •

Seneca said "Speak that I might see thee." You would have thought he should rather have said "Speak that I may *hear* thee." But the seer was a canny old soul and knew exactly what he meant to say. As a writer, I, like Carolyn, am very aware that who I am is written all over a clean white page. My personal integrity—or lack of it—is clearly and publicly communicated through words. It's a risk you take—a necessary risk—the fulfillment of a destiny.

As an artist Carolyn Blish is visible—painted
on the canvas of her memories, captured for
us between the covers of her book. Her heart
is here—seen in her celebration of childhood.
Her awe of the perfection of small created
things and the significance of life lived in all
its dimensions holds the eye and pleasures
the spirit.

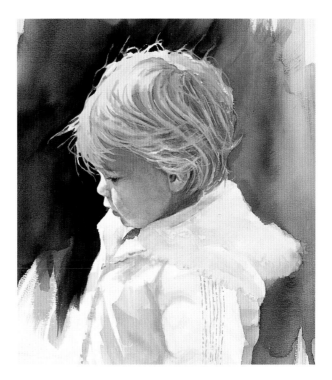

Above all, her focal point is seen to
be the creator God—in whose image she is
made and whose company she relishes as she celebrates her relationship
with him. This—this she longs to share—and does so, her way, with papyrus,
pen and heart. Read her, enjoy the scent of her faith and flowers; the
Carolyn-colors of her joy in God catch our breath and lighten up our
gray day. What a privilege to be a part! JILL BRISCOE

13

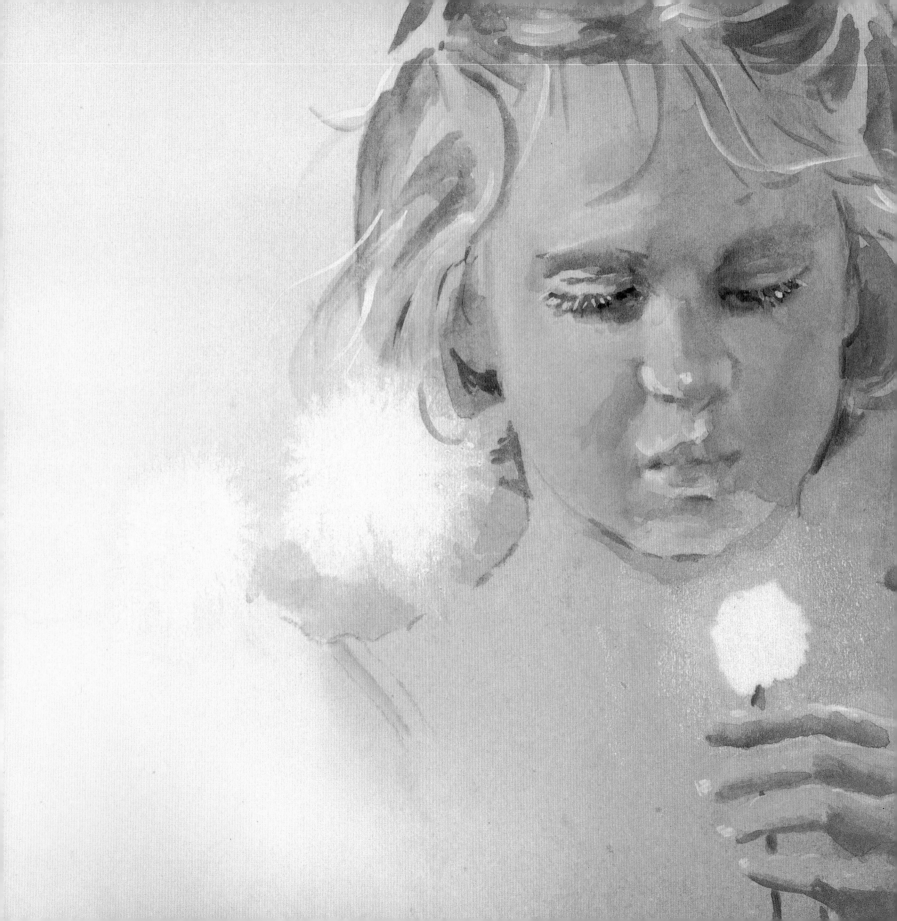

For the
Beauty
of the Earth

For the Beauty of the Earth

"The earth is the Lord's and the fulness thereof; the world and those who dwell therein."

PSALMS 24:1

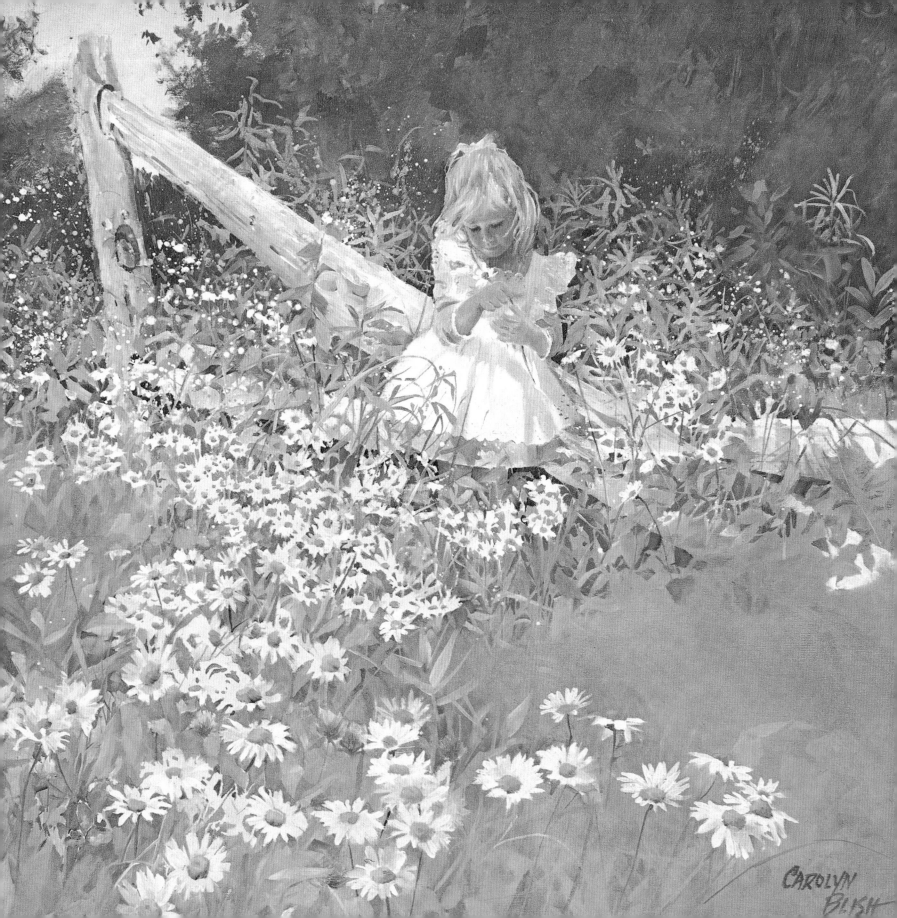

It seems to me that God has spared no extravagance to attract our attention, intoxicating our senses with all the lavish color and beauty of the earth's sounds, sights, tastes, fragrances and textures.

As long as I can remember, the realm of nature has inspired in me feelings of delight, wonder, gratitude and awe.

• • •

As a child, I loved wading through fields of dandelions gone to seed; I loved to pick them, make a wish, blow their perfect silver spheres into sprays of flying seeds. Then the wind would scatter them far across the field, back from where they came, to the earth where they would sleep in the sod until, at a nod from God, they would sprout again—a whole new generation of bright golden buttons, splattering an emerald field. I couldn't have put it into words, but somehow I knew with happy certainty that sunny fields and gossamer-

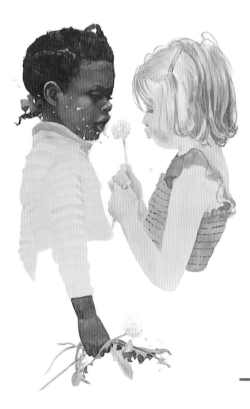

winged dandelion seeds—and even the games I liked to play with them—are all part of God's wondrous plan.

• • •

Flowers are a recurrent motif in my paintings because my paintings come from my heart, and my heart, like Wordsworth's, leaps up when I behold a field of golden daffodils, a hedge of wild roses, a lilac in bloom. The smallest clump of violets in a rock garden brings me joy I long to express.

• • •

My grandfather introduced me to flowers, taught me to look into their faces, to spell "nasturtium." The essence of flowers is softness, openness. It should be the same with our hearts. Are you waiting for someone to apologize? Ask God to help you forgive fully and lay it aside. Love heals with a hug and rewards the hugger with the flower of a smile.

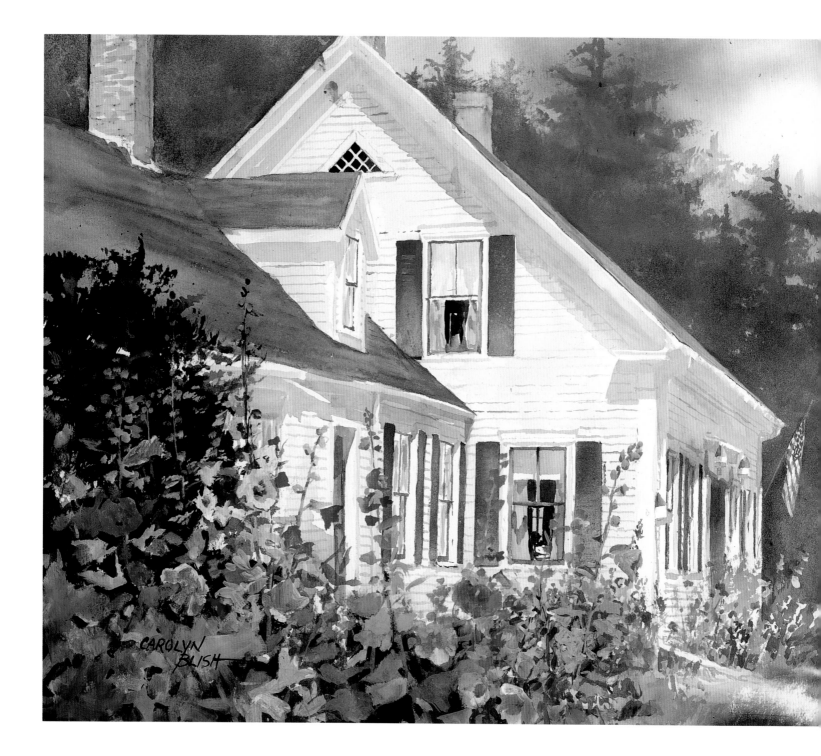

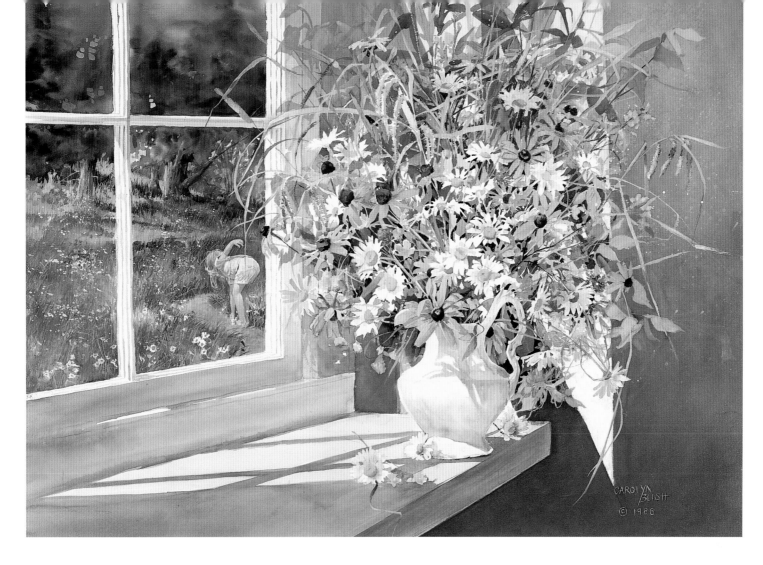

"As for man, his days are like grass; he flourishes
like a flower of the field; for the wind passes over it,
and it is gone...But the steadfast love of the Lord
is from everlasting to everlasting..."

PSALMS 103:15–17

21

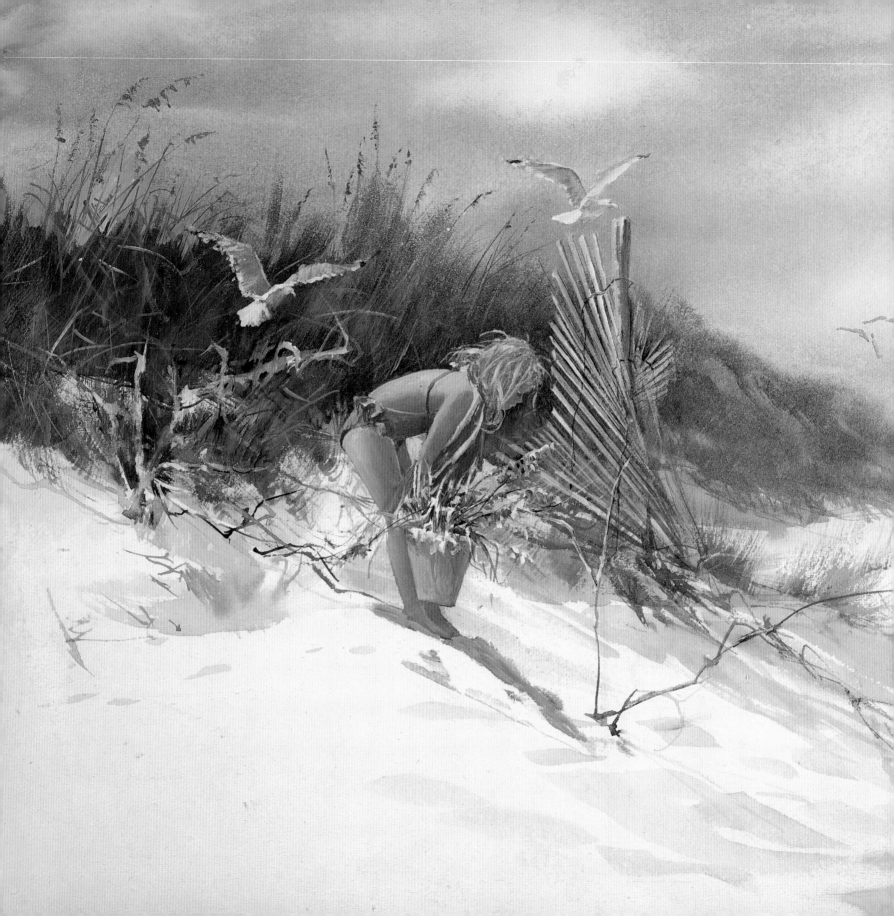

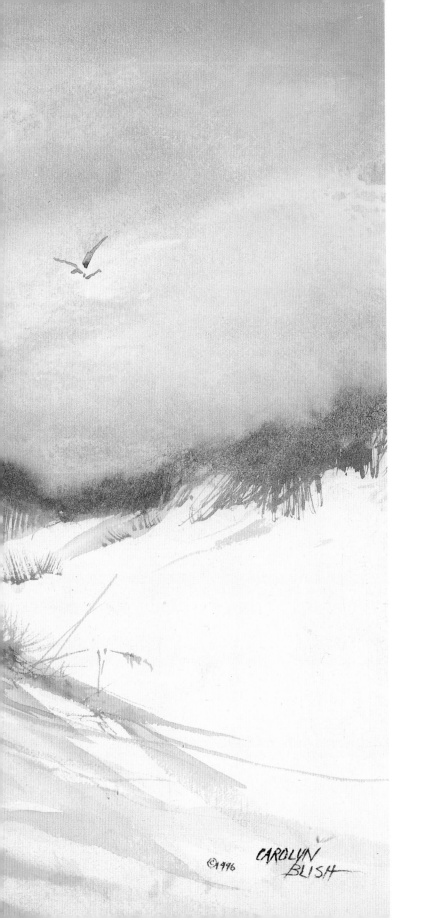

I grew up on beaches, could swim before
I could walk, spent whole days climbing
dunes, collecting shells, watching gulls
and finding treasures in the sand.

• • •

I love the sound of the surf, the way beach
grass dances in the wind, the smell of salty
sea air, the way tidal pools reflect the sky.

"The sea is his, and he made it…"

PSALMS 95:5

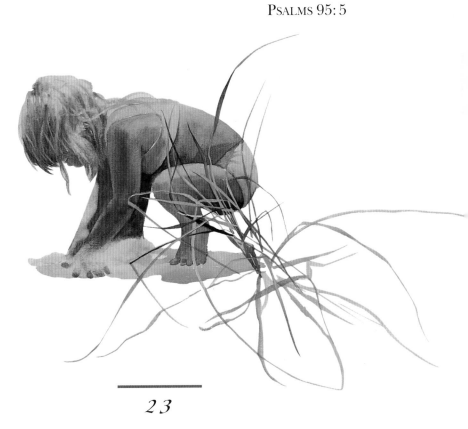

23

On the Maine island where we now spend our summers, there are no beaches to walk along, no rippled dunes yielding constantly to the wind. Instead, there is a spectacular rugged coast of immovable, gigantic ledges. These windswept headlands guard our island like silent ramparts.

Then, without warning, the wind rises, hurling waves against the ledges in crashing onslaught. All the sounds of life on the island are blanketed by the roar of wind and the thunder of the surf as mighty breakers splatter and splinter into diamond spray.

• • •

Who could doubt the power of the maker of a sea?

"If I take the wings of the dawn,
If I dwell in the remotest part of the sea,
Even there thy hand will lead me,
And thy right hand will lay hold of me."

PSALMS 139: 9–10

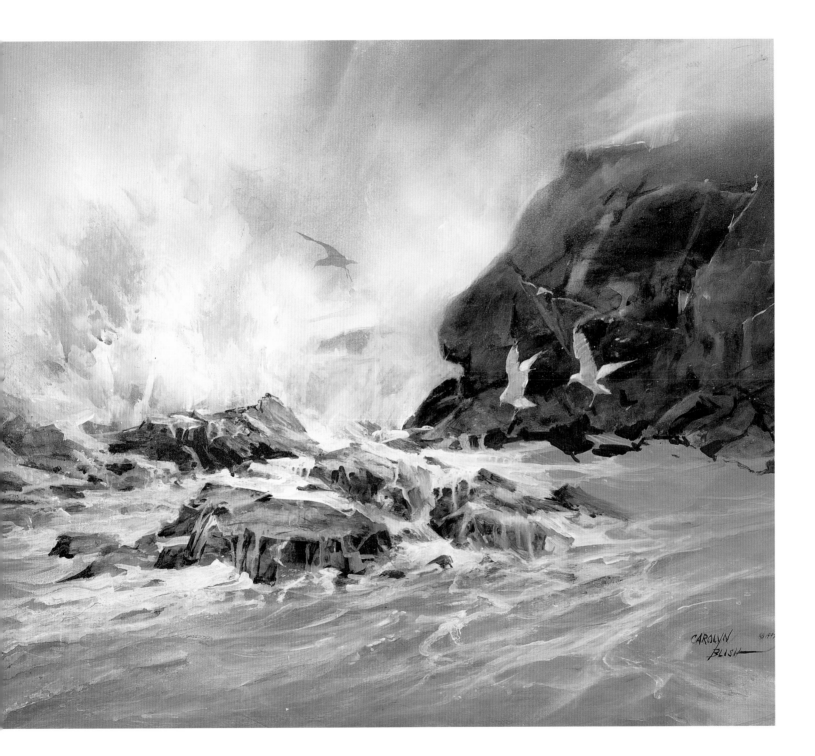

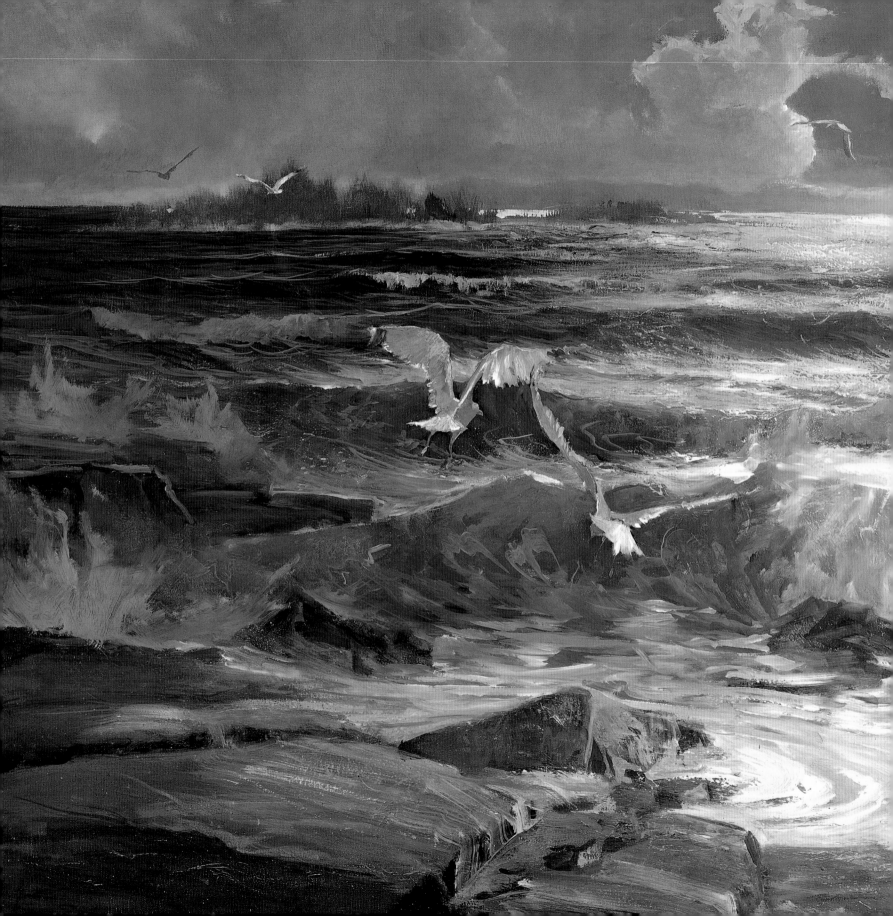

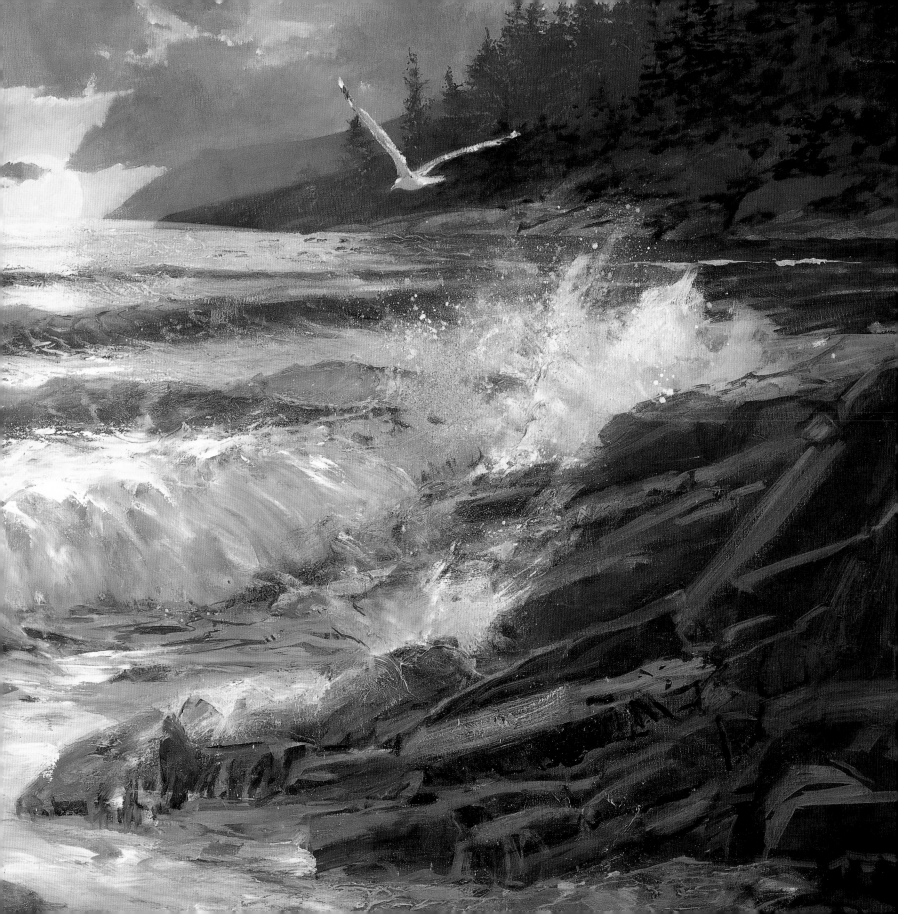

For the beauty

 of the earth,

For the glory

 of the skies,

 For the love

 which from

our birth

 Over and

around us lies.

FOLLIOTT S. PIERPOINT

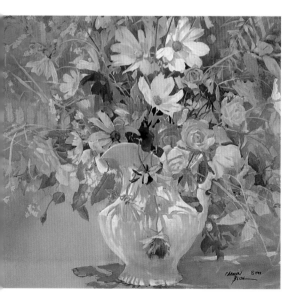

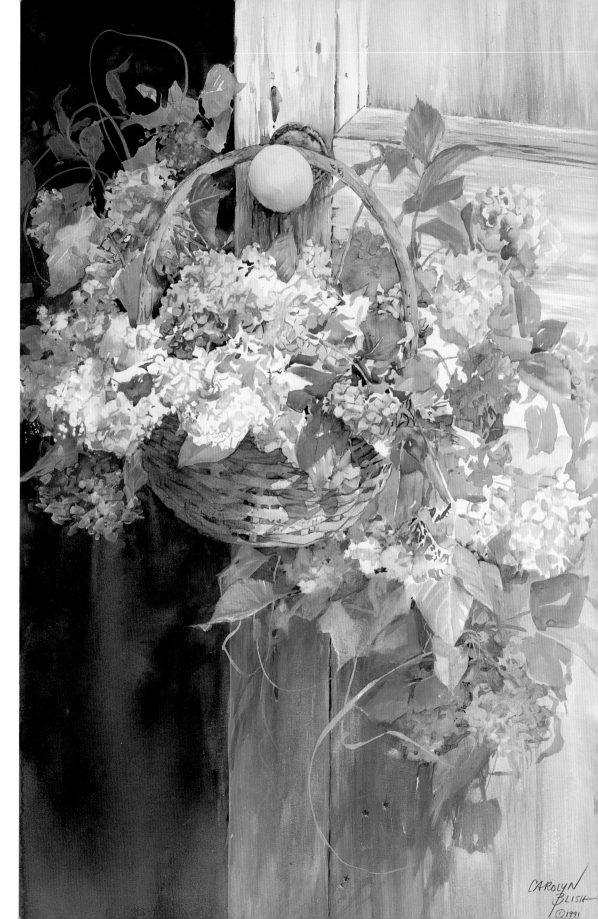

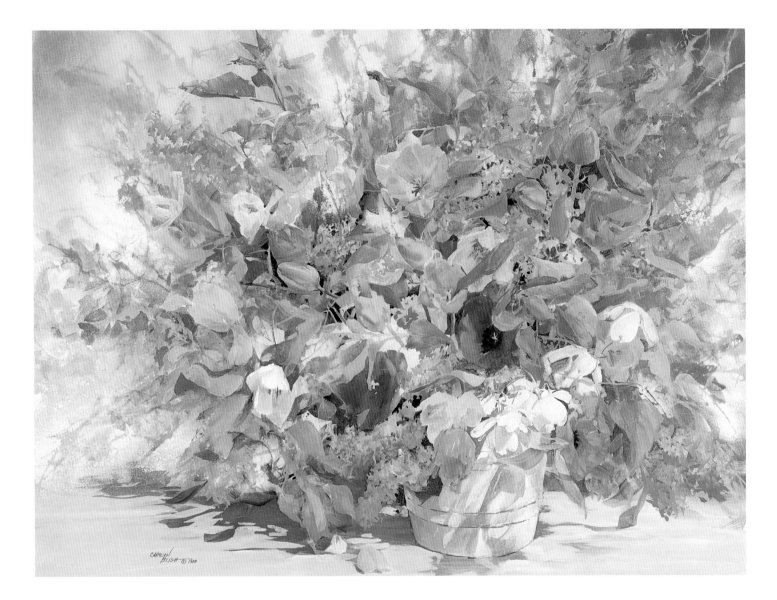

I know that it's officially spring when I find, on my doorstep, a bucket of tulips, lilacs and dogwood: my annual gift from Mike, a dear friend of many years who loves to share the spring bounty from his garden. I paint the tulips in crisp and bright colors in honor of their bravery, but I mute the lilacs in a dreamy softness that reminds me of their haunting fragrance.

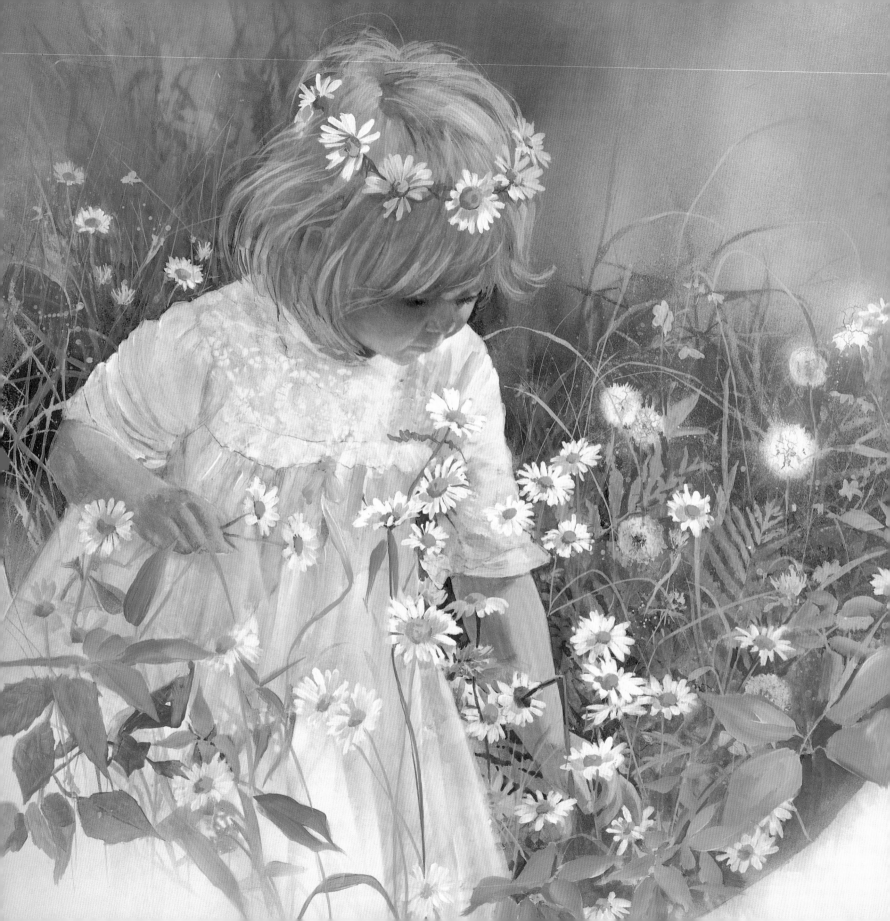

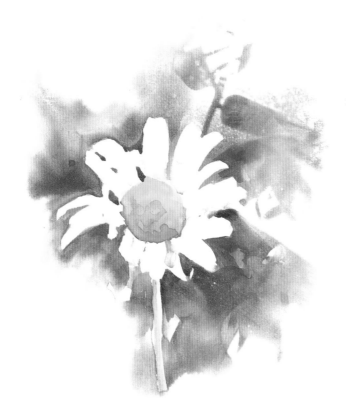

On a Vermont summer day when I was
five years old and had picked all the daisies
I could hold in my chubby fist, I ran
home and gave them to my mother.
"Do you like them?" I asked.
She turned to me and said, "I love them
because you picked them for me."

"Beloved, let us love one another;

for love is of God . . ."

I JOHN 4:7

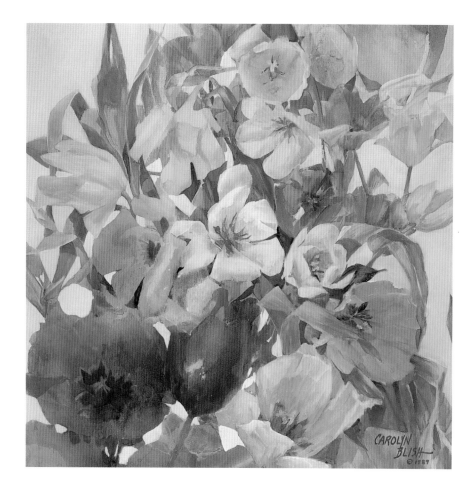

Flowers are a bridge to the past. Each year they
are reborn, fresh and fragrant, eternally inviting.

"Nature is the living,
visible garment of God."

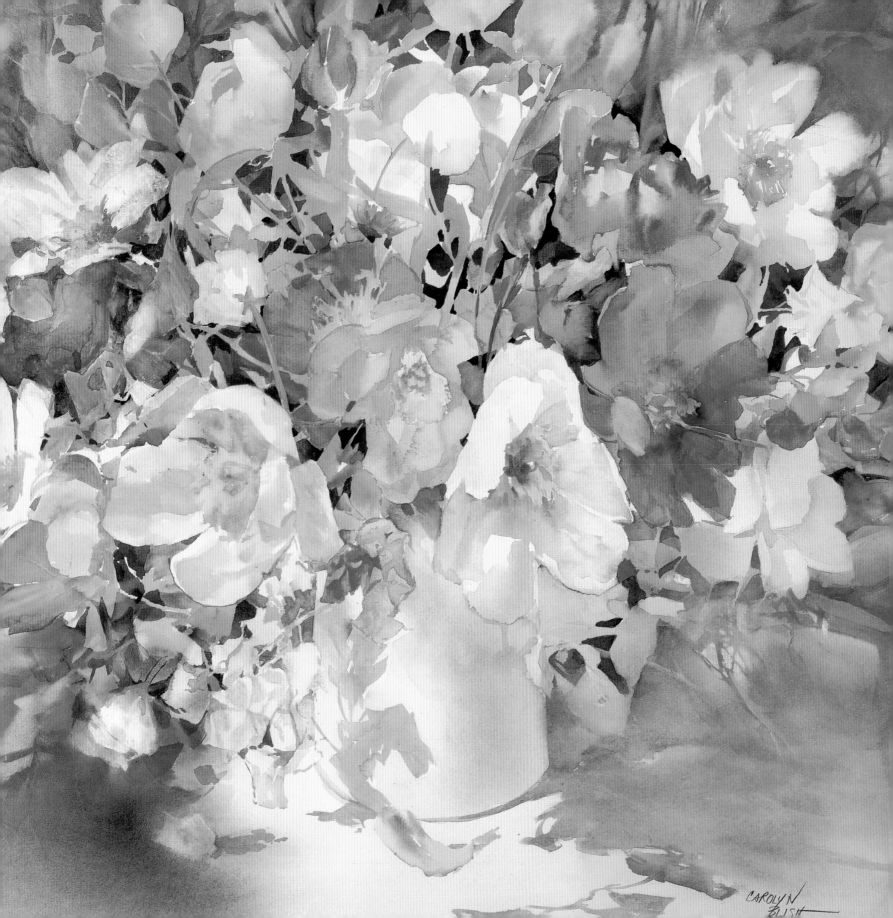

CAROLYN
BLISH

*H*ave you ever run through country air to a sunny meadow to pick daisies there? Have you braided them into a chain or a crown for your hair? Have you plucked their crisp white petals one by one, saying to yourself, "loves me, loves me not"?

• • •

Daisies surely are the love flowers, and I do love painting them. Look closely and you will see where long ago my husband and I carved our love for each other into the weathered wood of our old Vermont cabin.

"…for lo, the winter is past…
The flowers appear on
the earth, the time
of singing
has come…"

Song of Solomon 2: 11, 12

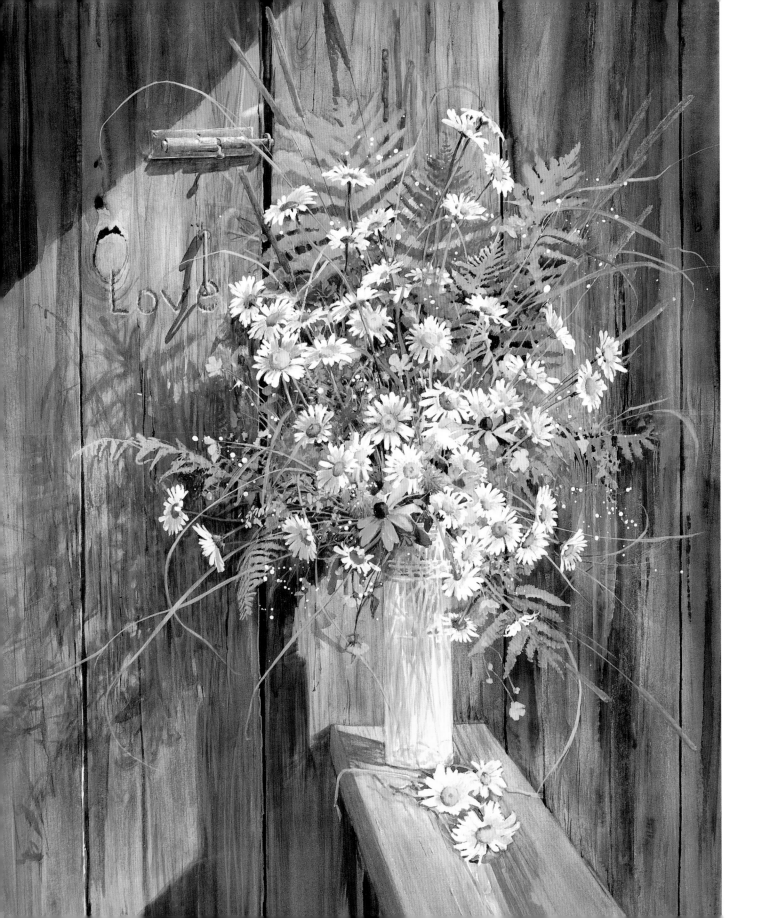

Near our home, there is an ancient dry-stone foundation where a house once stood. It is deep in the woods. I discovered it one day when I was searching for wildflowers. Saplings and vines spring from its cracks, and there is a stand of daylilies nearby. But they are no longer blooming. The forest has taken over, blocking out the sunlight.

I have transplanted many of those daylilies to my garden. It's a lot of work, but in summer, my back garden is a showplace of glorious color: lemon yellow, orange, pink, garnet and Chinese red.

• • •

Our summer cabin was on a lake, high in the mountains, in the midst of an evergreen forest. There were water lilies on the lake, and the forest floor was a crunchy carpet of twigs and pine needles dappled with sunlight. Green arches met overhead. In the early morning and toward dusk, it was like being in a cathedral.

• • •

The earth is God on exhibit!

37

Every day, God spreads his wonders before us, but we are not always paying attention. We have eyes but do not see. I remember one early morning when I went out into our backyard to paint. It was a gray day without the sparkle of sunlight. No color brilliance. No beautiful sunlit patterns. No cast shadows. For me, the verve of the moment was missing.

Nevertheless, I picked up my brush and began to paint. Inspiration sometimes follows when it does not lead.

Suddenly I stopped in the middle of a stroke. A monarch butterfly had alighted on the handle of my paintbrush.

I kept my hand absolutely still as I studied the dramatic orange and black markings of the monarch. For a moment it hovered there, fluttering its wings so that the patterns shifted and changed, like a kaleidoscope. Then it lifted away in darting parabolas.

I looked around. The landscape was ignited with expectancy. Everything was fresh and new. Nothing was small or insignificant. I was changed, too: eager, excited and drenched with gratitude.

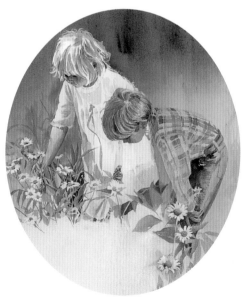

After all, God could have given us a black-and-white world, just the basics—water, food, air and a source of energy.

Instead he gives us butterflies.

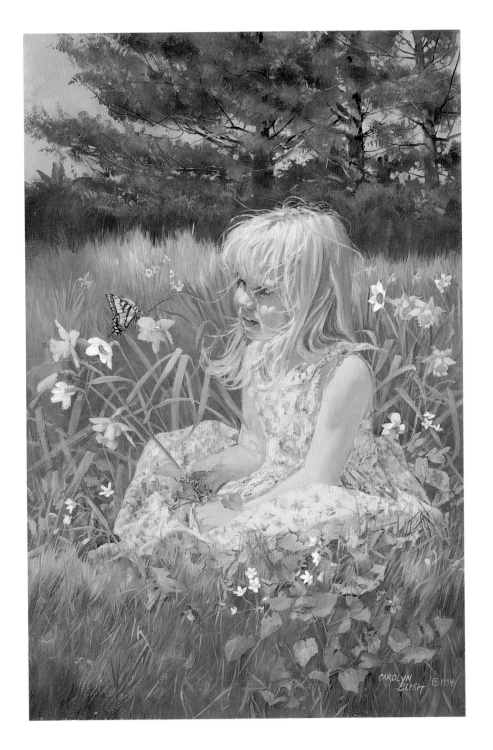

"*For by him
all things
were created:
things in heaven
and on earth,
visible and
invisible...*"

Colossians 1: 16

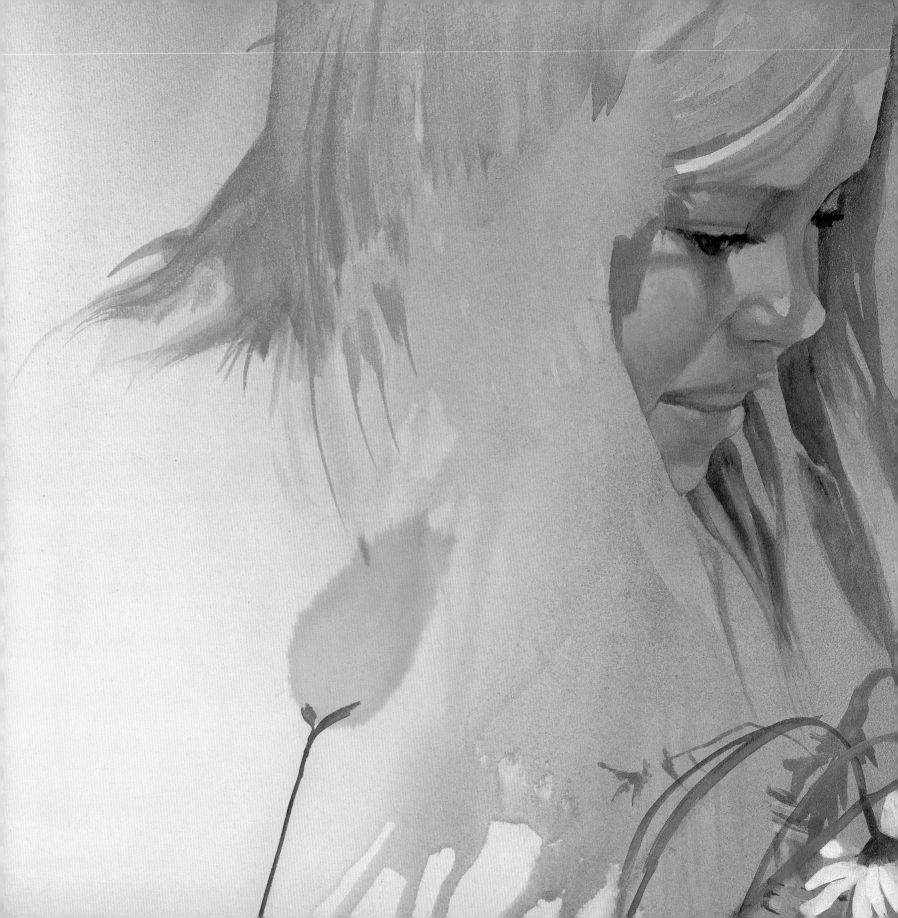

Every Good
and
Perfect Gift

Every Good and Perfect Gift

"So God created
man in his own
image…male
and female
he created them."

GENESIS 1:27

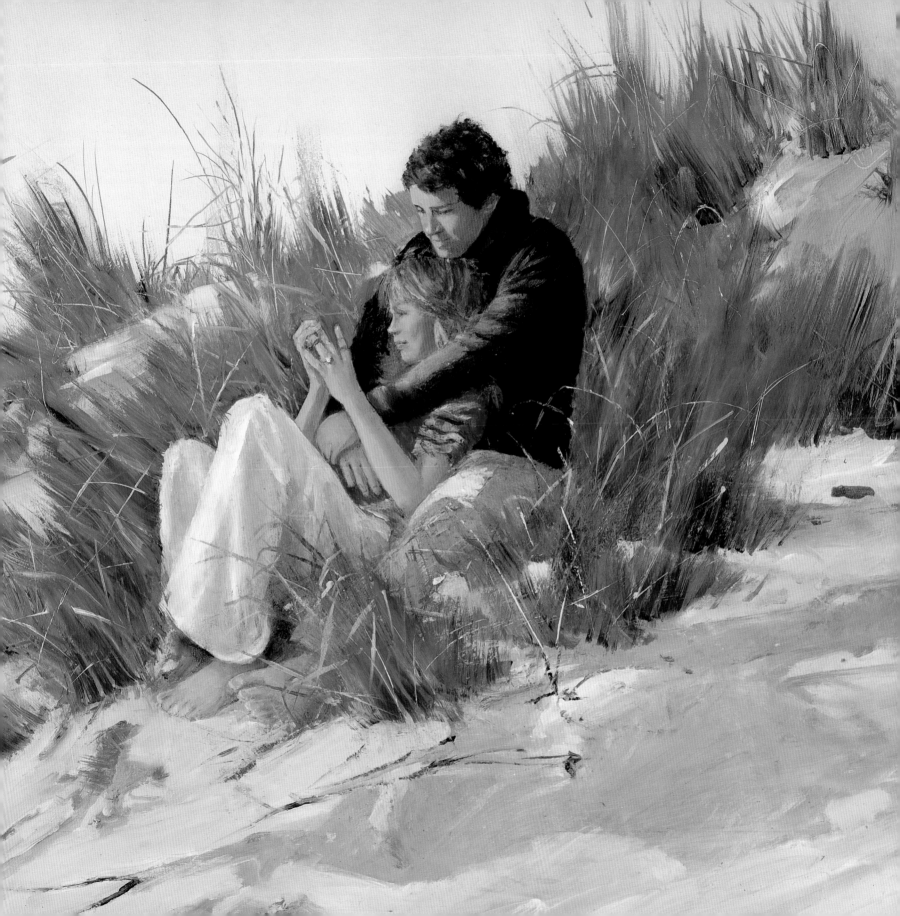

When God tells us we are made in his image, I believe he has creativity in mind. We're not all painters, of course, but we are all creators, using our God-given talents to turn dreams into reality: a vegetable garden, a poem, a comforting word, a suspension bridge, a blueberry pie, a smile on the face of a child.

• • •

I have heard so many people say, "Oh, I'm not talented at all." But creativity is not the restricted province of those who compose music, sculpt, write or paint. Each one of us has been born with something special— a gift for cooking, a gift for carpentry, a gift for teaching and listening, a gift for consoling and encouraging. Creativity is a way of living a life. The materials and tools are only incidental. Once I saw a fruit vendor on a New York City street corner making a beautiful design with mounds of fruit. It was a masterpiece!

• • •

One of my God-given gifts was a mother who cheered me on. Her equanimity in the face of my efforts to be an artist was remarkable, and I put it to the test at an early age when I

44

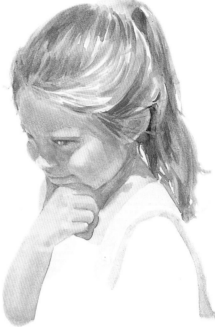

secretly decided to beautify the walls of my closet with magnificent scenes that I would design and paint. I would cover every inch of wall space with flowers, birds, animals, trees, sunsets and rainbows. I didn't care if it took a hundred years.

One day while I was in my closet happily painting, I heard footsteps approaching. My mother had been entertaining a friend and decided to show her a dress she had stitched. It was hanging in my closet. She threw open the door. There I was, covered with paint. After her first gasp of surprise, my mother stood silent, surveying my childish efforts. And then she turned and smiled and held out her arms.

"Why, Carolyn," she said. "You are an artist."

• • •

With that hug, a painter was born. I was so encouraged that I entered a poster contest the next week. The subject was ragweed. I didn't even know what ragweed was, but I joyfully painted a stalk of ragweed silhouetted against a big orange sun. It won the contest, and prints were made of it.

I still paint orange suns.

A word of encouragement may lead to a lifetime of achievement.

• • •

My mother had a special talent for encouraging others. But we all have the ability to make that call, write that note, wish others well, to sympathize when they are having a hard time, to believe in them and let them know that we do, to rejoice with them when they succeed. If our hearts are in the right place, we'll find the right words, the right things to do.

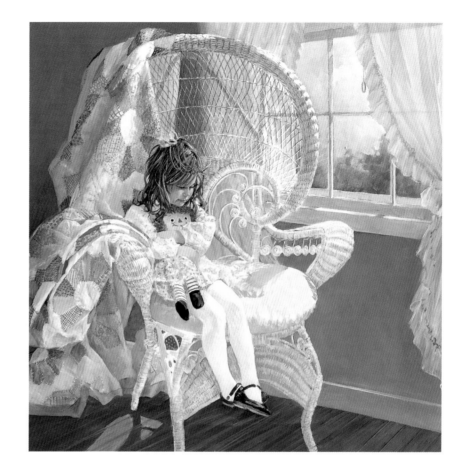

"...and a word in season, how good it is!"

Proverbs 15:23

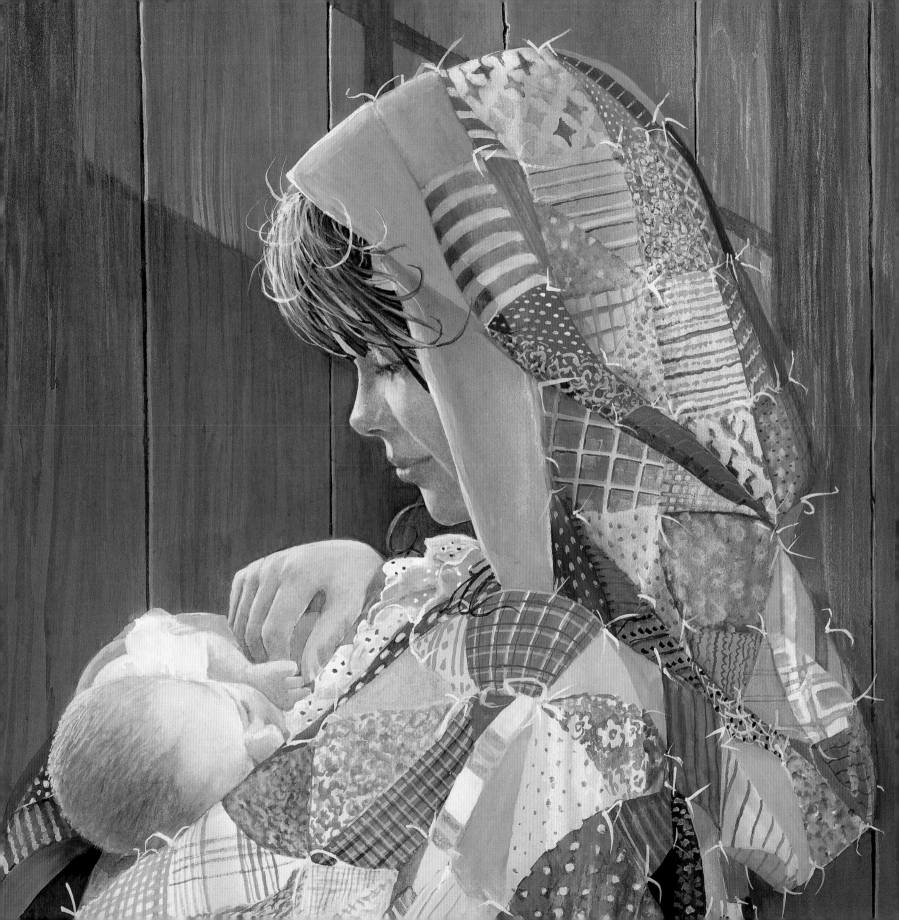

*I*n children, too, the need to be understood is very great. Because they're little doesn't mean their concerns are little. But children, even more than adults, tend to keep their hopes and fears curled tight inside. It doesn't do to pry. A rosebud needs to open petal by petal, to flower in its own sweet time. Love helps a lot. And sometimes small miracles happen.

• • •

For me, it was the time I inadvertently found a way to draw closer to the children who sat for me to have their portraits painted.

It began with a moment of discontent. I loved everything about my studio except the floor. It was dreary, mundane, boring. But it didn't have to be.

Deed followed thought with startling rapidity and before I knew it, I was down on my knees turning the floor into a painting. I began with a huge, luxuriant tree—great, over-arching branches, twigs and leaves, luscious fruit dangling. Words and phrases grew like vines around the tree. "The fruit of the spirit is joy, love, peace. . . .

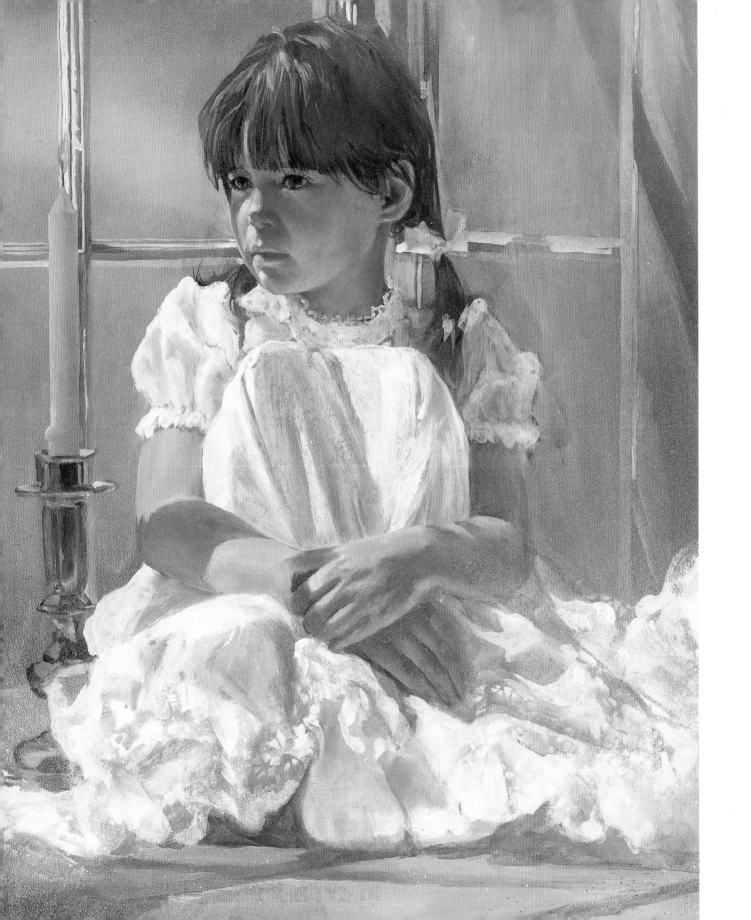

The roots determine the fruits. Let's be fruity!" I dipped my brush in bright yellow and underneath the image I wrote, "Don't be a lemon."

I laughed out loud. My brush had a mind of its own—and a saucy way of saying things. And why not? Who says truth has to be solemn?

I painted a bunch of flowers with a notation beneath them: "People aren't perfect—only flowers."

I painted balloons and butterflies, snowflakes and raindrops. I painted the tiny, creepy, crawly things of the earth, and the sun, moon and stars of the heavens. Pictures and words. "He hung the stars in the sky, and he calls each one by name."

• • •

When the children come, they are transfixed. The creepy-crawlies usually catch their attention first. Turtles and fish and frogs, slithering and leaping through starry galaxies.

Even the shyest youngsters begin to talk eagerly, excitedly, opening up like flowers so that I can see what makes each of them unique and can capture it in a portrait.

• • •

The gift is free, but we have to reach out to receive it.

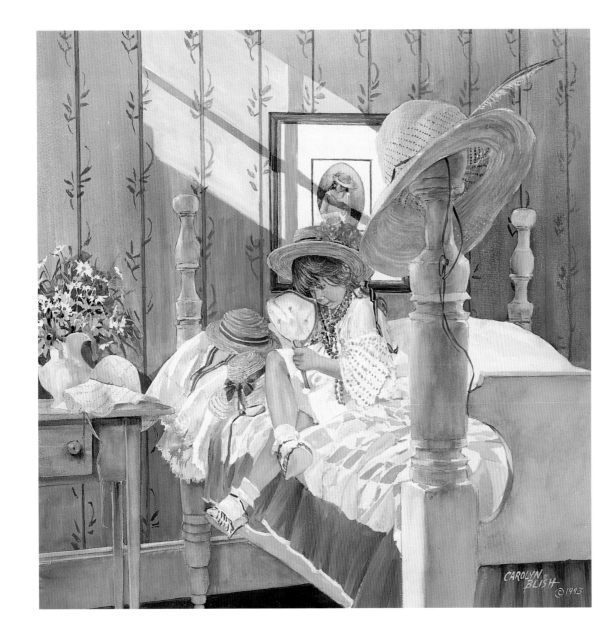

Small like me?
 Yes.
Playing in the stars?
 Yes.
Great and small,
God made them all.
God knows their names?
 Yes.
My name, too?
 Yes.

ELISE MACLAY

On that long ago day when I was found painting the walls of my closet, one of my mother's friends explained to me that my talent was a gift from God, a very special gift, one that would grow if I used it. The more I would draw and paint, the more God would multiply my talent. I remember thinking that the author of such an idea must be very wise and kind. It was the first time anyone had spoken to me about the Bible.

• • •

Again and again, God reminds me that faith is the outstretched hand that receives the gift. I stand before the white, blank rectangle of my canvas. An excitement that verges on pain sweeps over me. I visualize the finished work in its full composition and color. But the idea that inspires me will remain airy, nebulous, unseen until it is expressed on canvas. I have to get that brush in my hand and start moving it. When I do, each brush stroke leads to the next. Often, as I work on one painting, I get an idea for another.

Faith is visualizing the finished painting. Hope is the pigment. Conviction is the brush acting on the canvas.

"To everyone who has, more will be given, and it will be given in abundance…"

MATTHEW 25:29

52

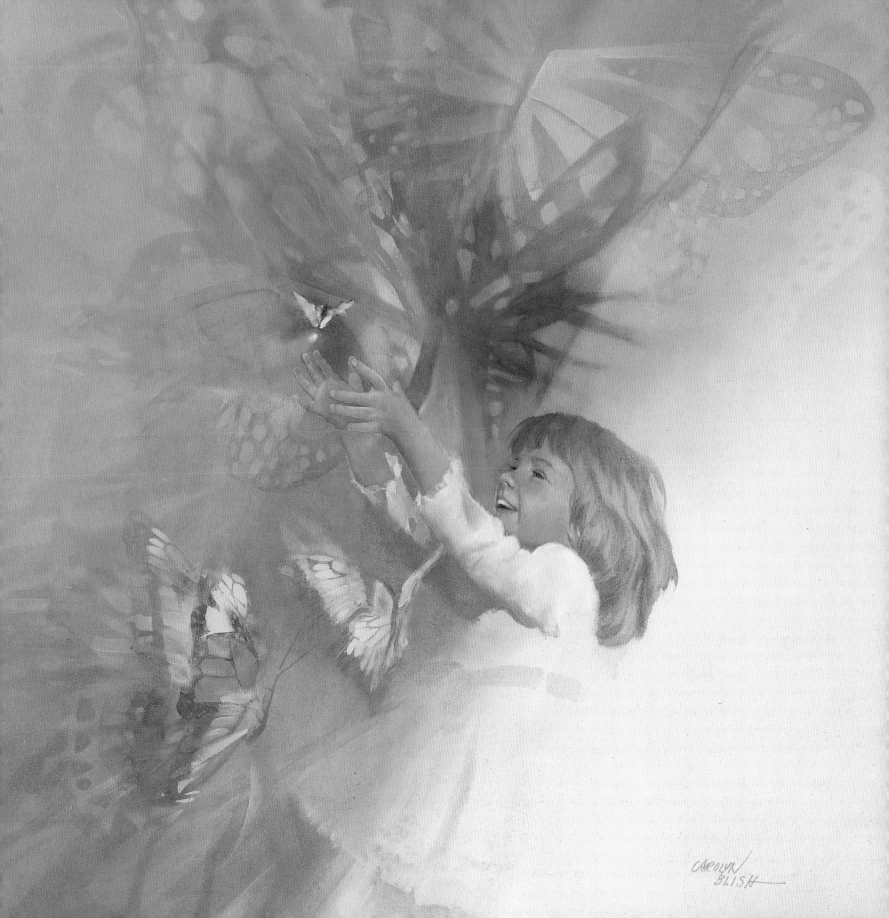

CAROLYN
BLISH

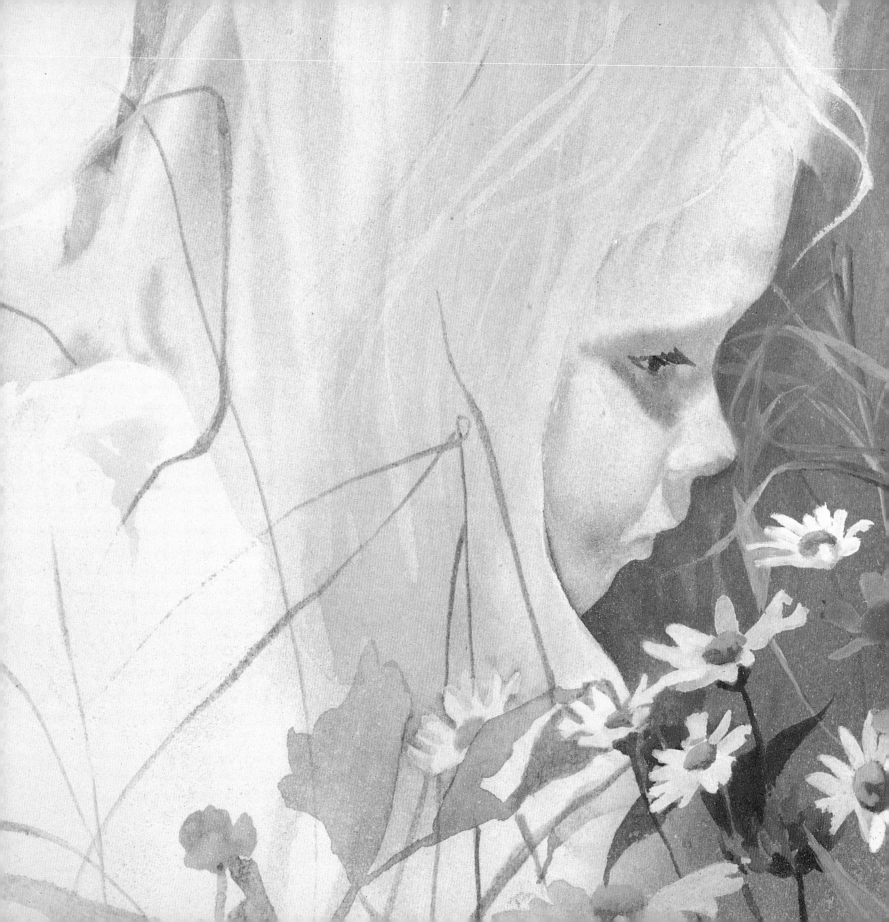

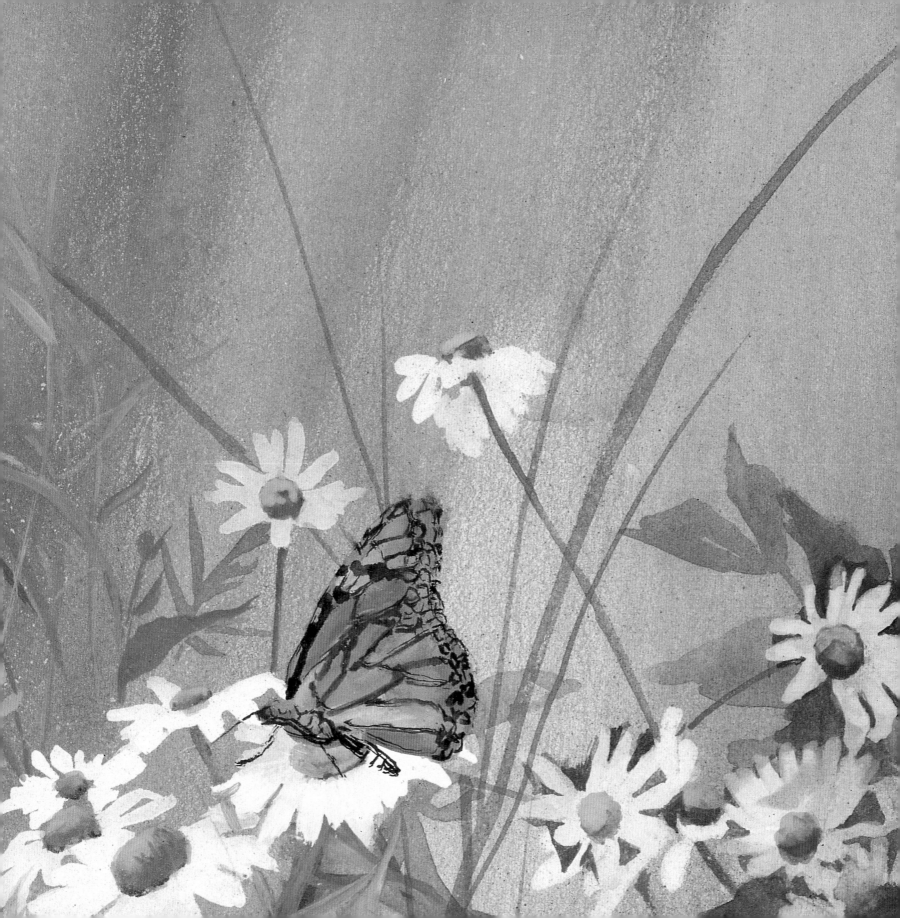

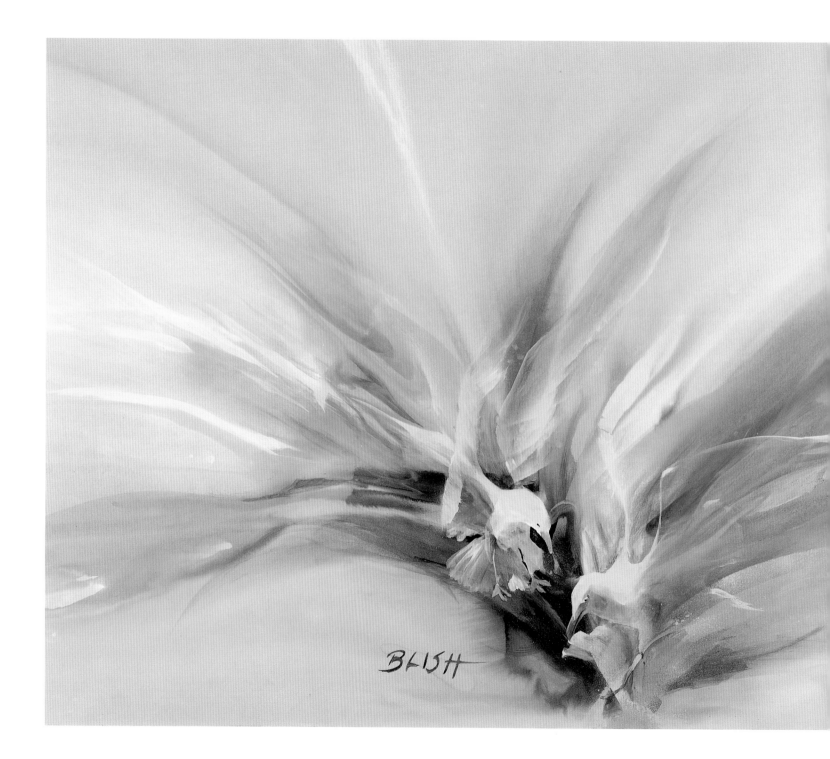

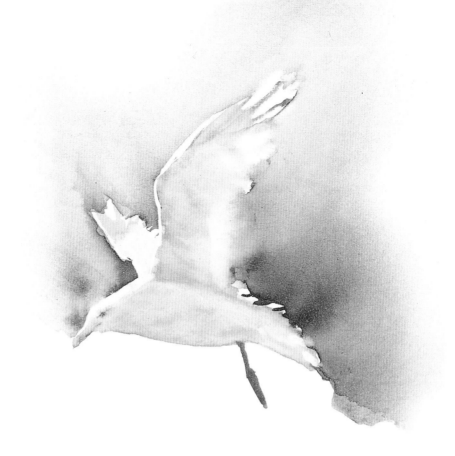

When I am in a creative state of mind, everything around
me seems to be infused with possibilities—even accidents. I once
spattered black ink on a finished painting. At first, I thought it was
ruined. Then I saw a way to turn my goof into an added feature.
I painted wings on the black spots and turned them into birds. God
does the same with our mistakes. He makes them beautiful, gives
them wings and flies them away as far as the East is from the West.

• • •

It is important not to be a slave to what we see.
Spirit, not subject matter, determines greatness.

To break free of the tyranny of reality, I sometimes flow water on a wet board. I hold a garden hose with my left hand and pour or brush on paint with my right. I tilt the board this way and that. Where I want more movement, I add water. Watching the spreading shapes of colors, I take care to preserve the precious white or negative areas.

My imagination goes wild as I watch the streaming paint and start to see things in the shapes. When I get a clue of something, I set the hose aside and start to modify the painting, crystallizing the idea. Different rhythms appear subtly and spontaneously here and there. As I find them, I encourage them; and these accidental happenings become the heartbeat of the work.

• • •

Color streaming across the paper is like liquid love.

58

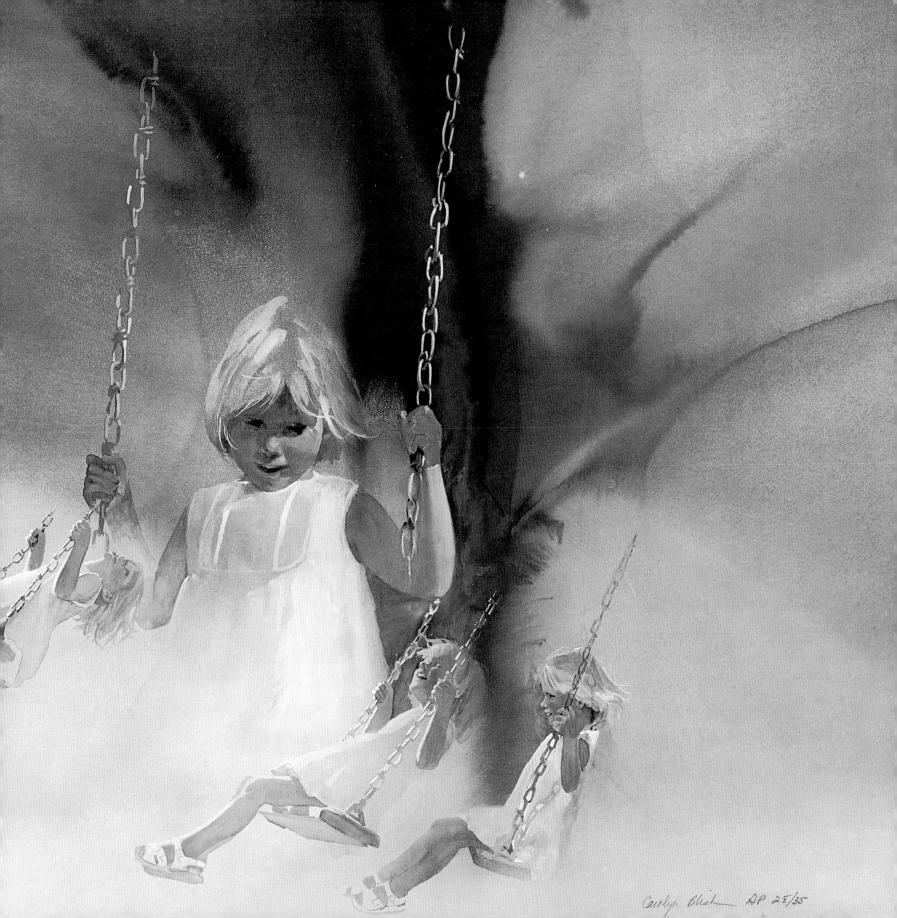

Carolyn Blish AP 28/35

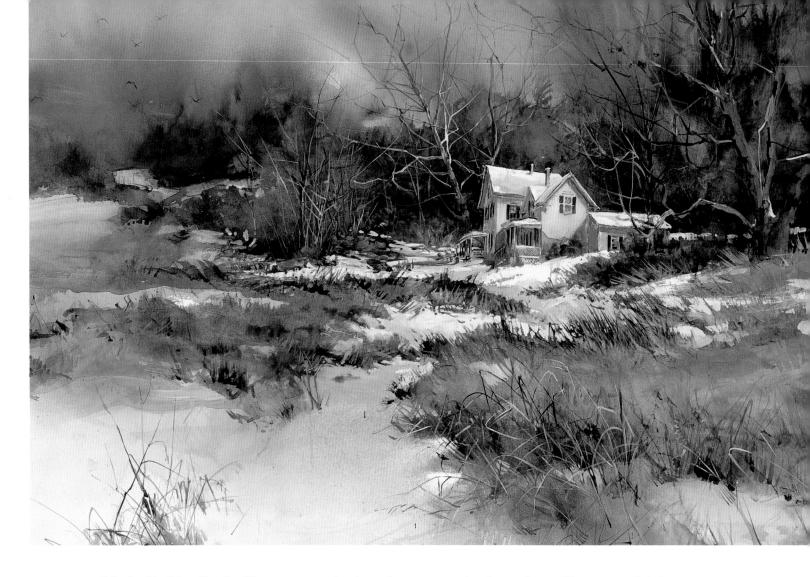

My belief in God affects my painting, but my painting also affects my faith.

Painting restores me, breaks my heart, humbles me and shakes me up. But it always pulls me back to God for his strength. My own keeps fizzling out.

Sometimes when I am a few hours into a painting, the thoughts that inspired me in the beginning seem remote and unreachable. I can't even recapture whatever prompted me to paint it in the first place. I start to falter and fumble with the mess on my easel, which looks like a gigantic mistake, yet pleads not to be forsaken.

I decide to go the extra mile. Turning not inward but upward, I ask for a

right spirit to be renewed within me. Sometimes my enthusiasm returns almost at once.

More often, I must actually begin the tiresome chore of revision and repainting.

But sooner or later, love enters the picture and a fresh new work emerges.

• • •

Some of life's most fulfilling moments are spent salvaging failures.

• • •

God sees the potential in every messed-up life. We can't throw away the canvas,

but smudges and smears can be washed away by God's forgiveness; and with his help,

our lives can become the masterpieces he intends.

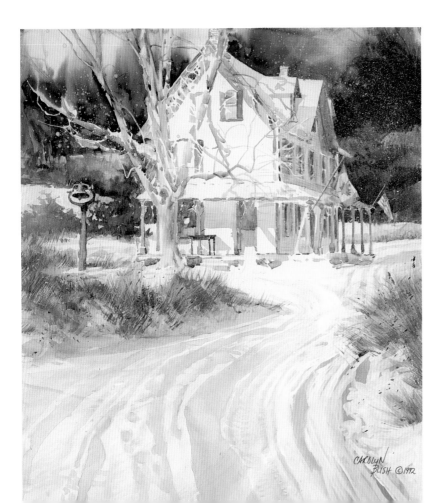

"Therefore, if anyone
is in Christ,
he is a new creation;
the old has gone,
the new has come!"

II CORINTHIANS 5:17

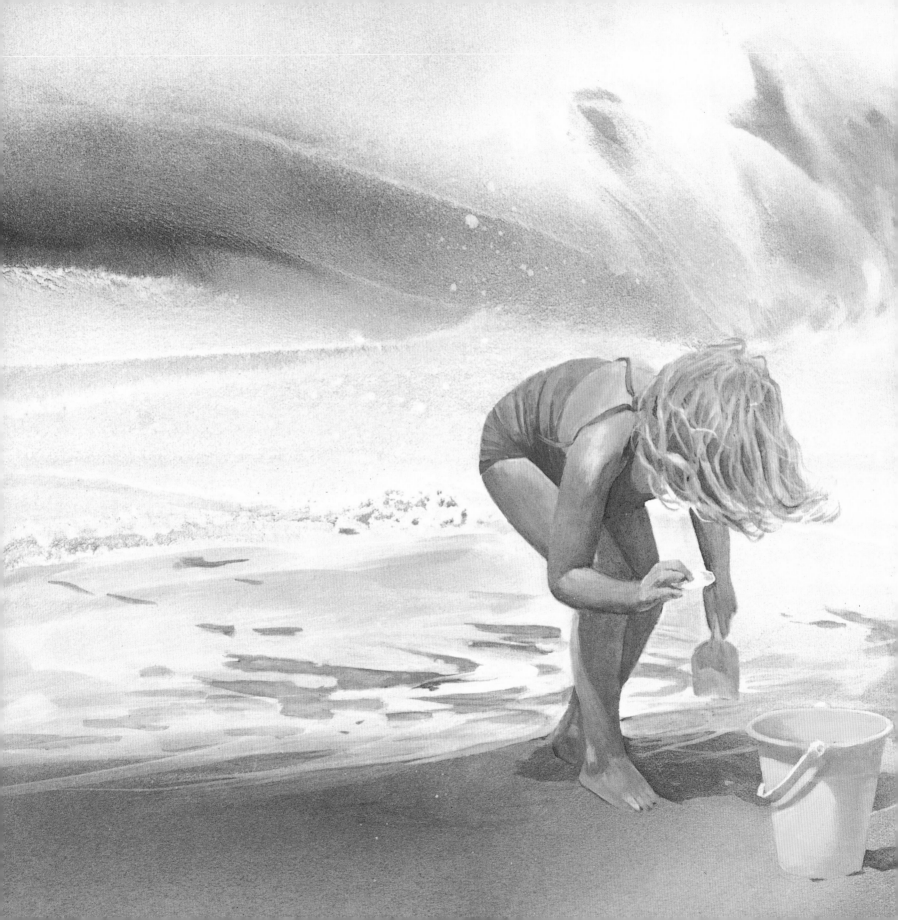

Holding Wonder

"For where your treasure is,

there will your heart be also."

Matthew 6: 21

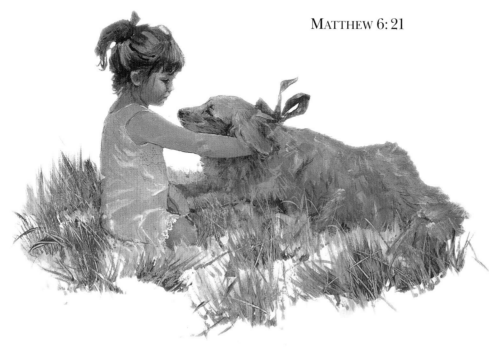

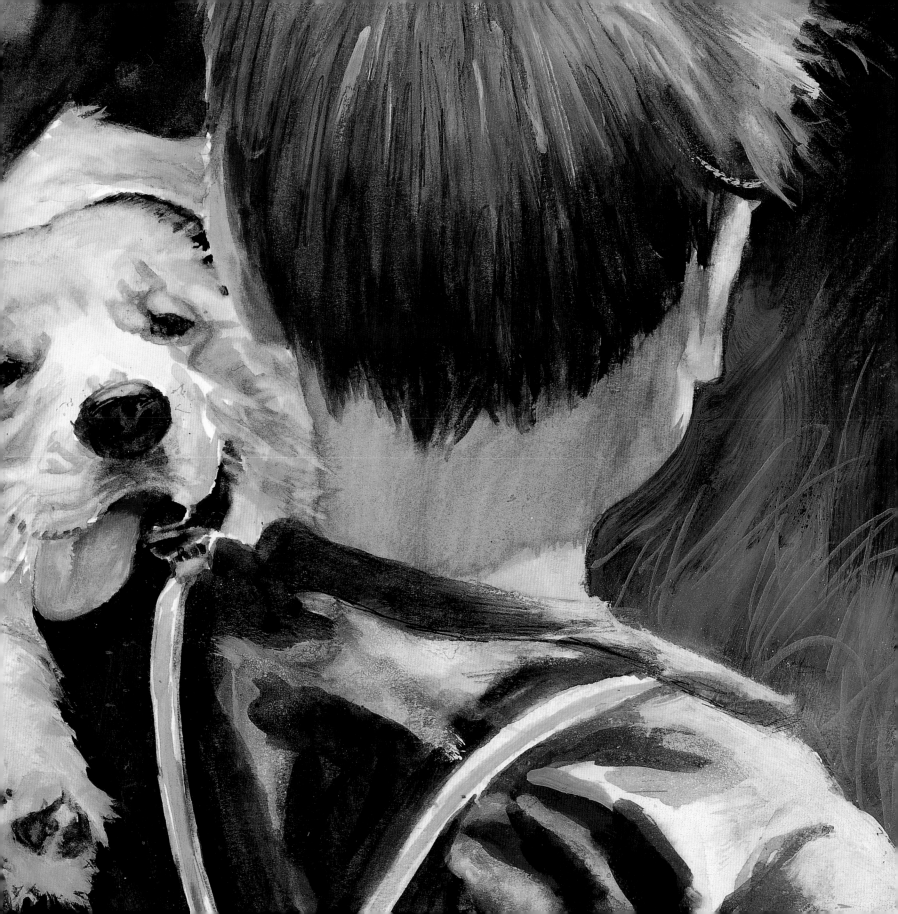

*L*ove makes the world go round, but wonder makes it shine. Call it a feeling of awe or holy adoration; it sparkles and glitters and lights up the soul.

Sometimes wonder crashes over us like thunderous surf, picks us up and carries us away. At other times it is like sea mist, essence of water, weightless, saturating the world, diluting its pain, wrapping its wounds in diaphanous gauze.

Usually wonder is a solitary thing, but sometimes it is possible to glimpse it in the eyes of a child.

• • •

Christi, my granddaughter, picks up a shell and gazes at it spellbound. I ask what fascinates her so. "Can't you see? It's the whitest shell in the whole wide world."

• • •

Why do we, as we grow older, lose the capacity for undiluted joy and delight?

• • •

Children move me more than the most spectacular

scenery in the world. I love
being around them. Their
complete abandonment to
their activity, their natural vitality
and humor, their innocence and warmth
are beguiling, and their candid conversation without
pretense absolutely captivates me. Their total absorption in
the present is no small thing. They squeeze and drink up to the last drop the
essence of the moment, letting it drip down their chins.

• • •

Children somehow know how to let happiness creep up on them. They
don't run after it. They simply expect it to overtake them. And it does.
In a child's world, everything is where it should be. Happiness happens.

• • •

When I started painting children, it was like opening a door that time had
closed. I began seeing things as if for the first time. I became the eager,
questioning little creature I was so long ago.

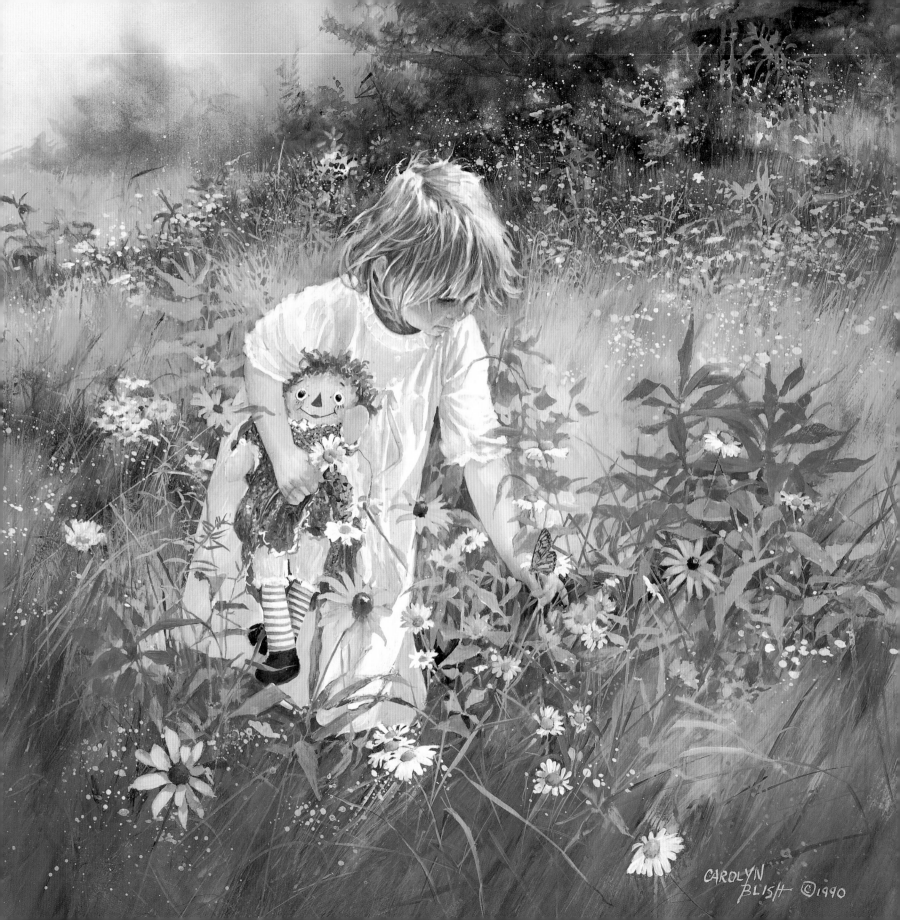

CAROLYN
BLISH ©1990

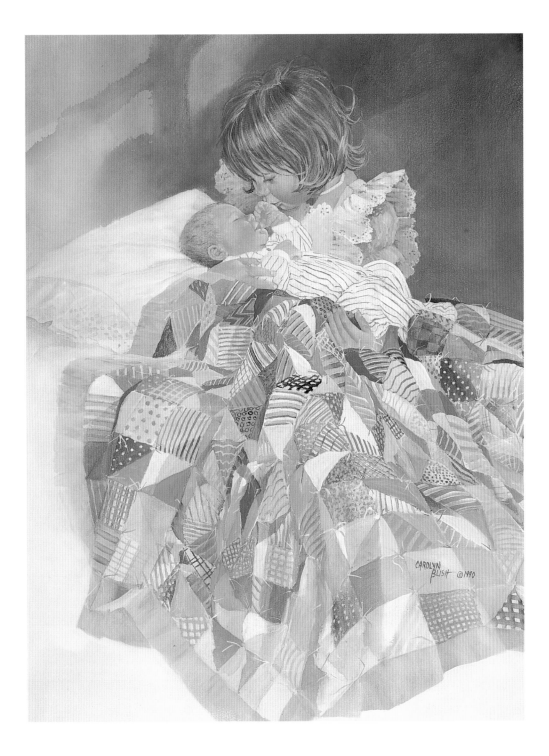

I was three when
my grandfather gave
me a kaleidoscope.
I held it to my eye and
would not take it away.
It became my favorite
toy. I never tired of
watching those stained
glass windows opening
on an endless array
of happy surprises.
I think that was when
I fell in love with color.

69

*C*hildren and artists have a special way of looking at things. When my mother bought me a coloring book, there wasn't room for all my ideas. So, instead of coloring inside the lines, I filled the margins of the pages with drawings of my own invention—houses, trees, flowers—even my pet cat, colored hot pink.

My mother laughed and praised my originality. Unfortunately, my junior high school art teacher was less understanding. She had asked each student in the class to paint a horse. With great joy I painted a purple and pink polka-dotted pony. Just before class ended, the teacher collected our artwork, perused it and held up my painting. She said, "Anyone who looks and really sees, knows that there is no such thing as a pink and purple polka-dotted horse. Carolyn has not painted the truth. There's no talent here." Then, to my horror, she tore my painting in two and dropped it into the wastebasket.

• • •

I dragged myself home from school that dark day, too crushed and shy to protest that the day before, my father had taken me to a carnival where there was a merry-go-round and I had ridden … on a pink and purple polka-dotted pony.

———

70

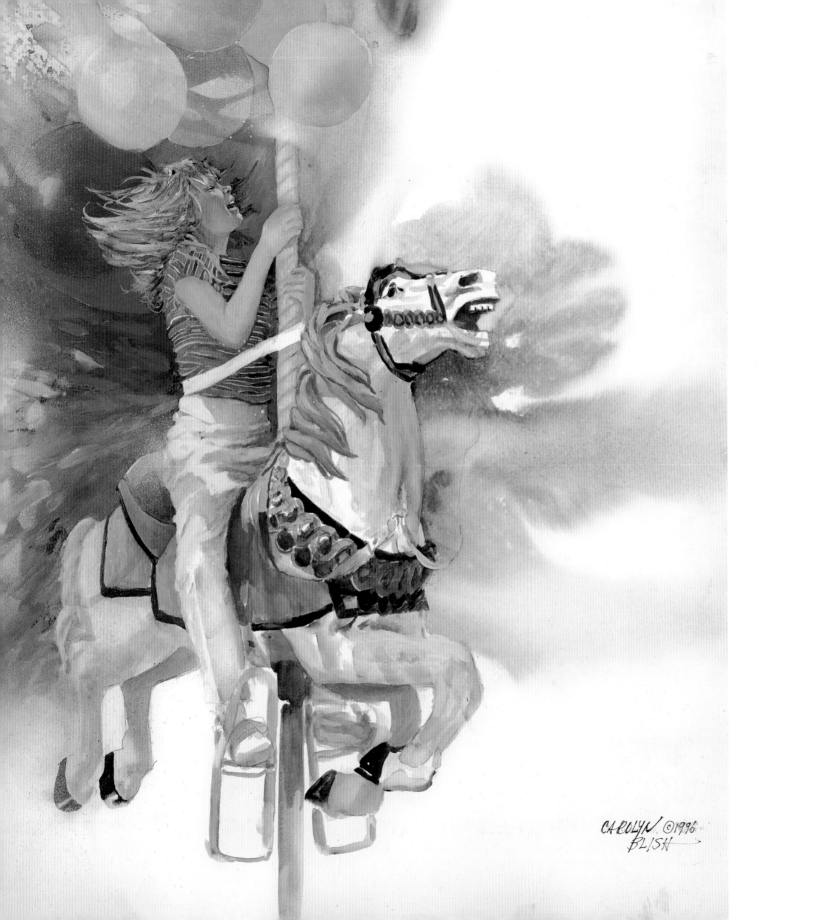

CAROLYN ©1996
BLISH

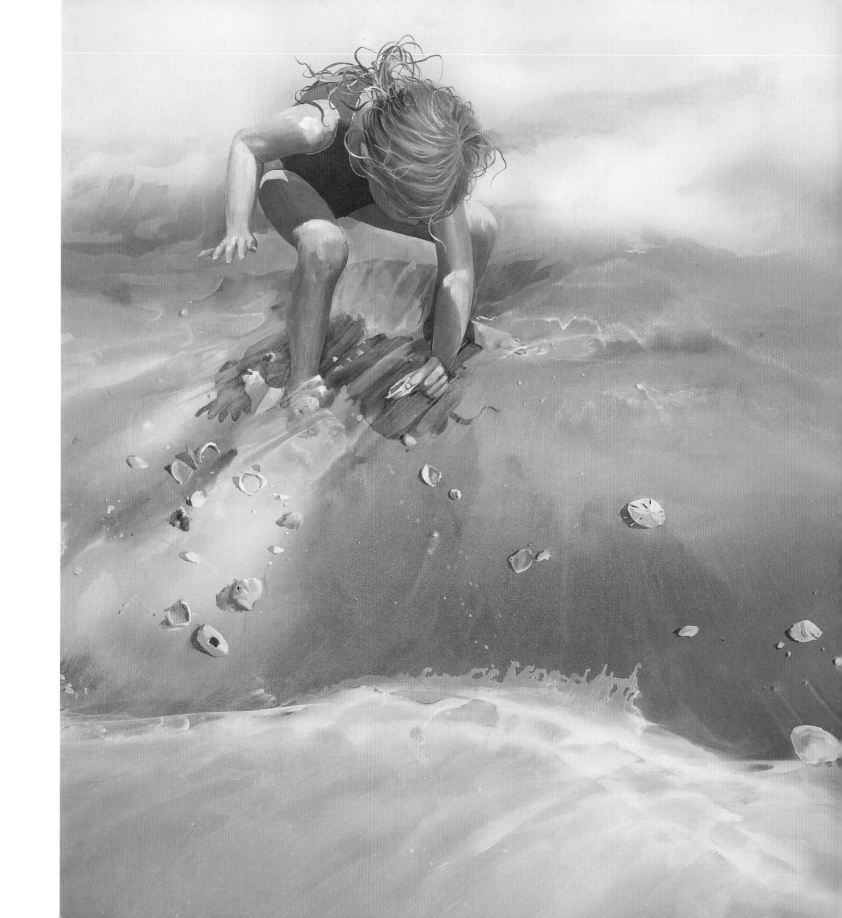

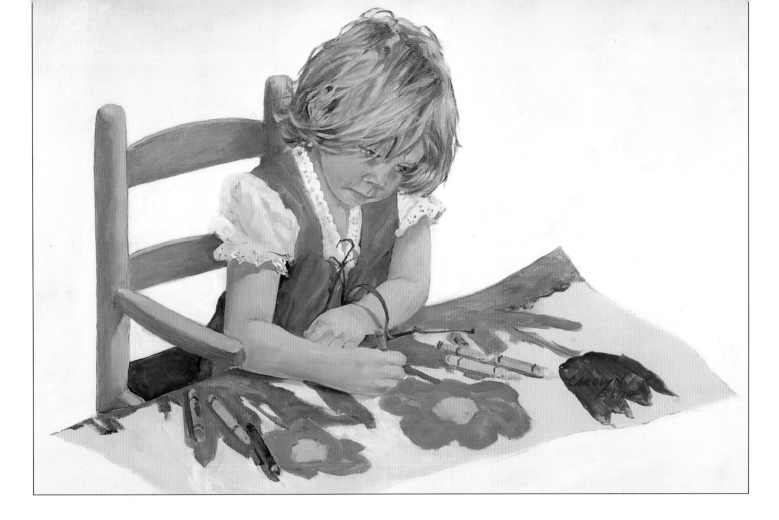

Grab your crayons and let's color, color outside the lines.

You'll never know what we'll discover or what new worlds we'll find.

Imagination will unwind when we color outside the lines . . .

Green horses jumping over stars, wheels on people, feet on cars,

Dancing houses wearing skirts, gorillas riding geyser squirts.

Butterflies and bumblebees need room to dance—

More paper please !

LES JULIAN

73

Outdoors, on their own, away from grown-up commands to "calm down" and "take it easy," children gallop and prance, hop, skip, jump and race like wild horses, like birds in flight, like the wind itself. A child's boundless energy is God-given and truly wonderful, but like many lovely things, it is fleeting, so we can only cherish it, remember it and, if we are artists, memorialize it in a painting or a song.

"This is the Lord's doing; it is marvelous in our eyes."

PSALMS 118:23

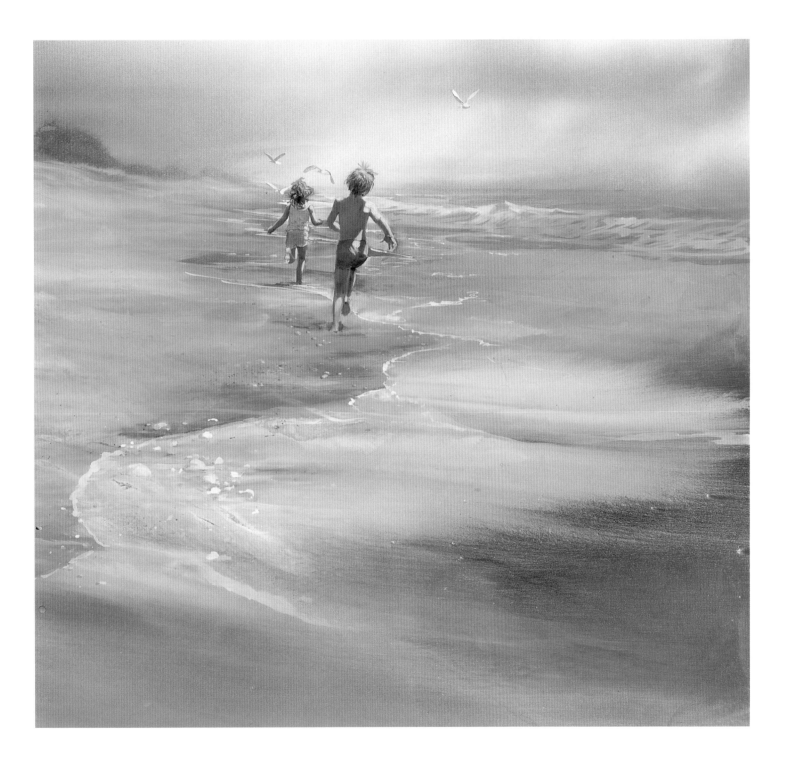

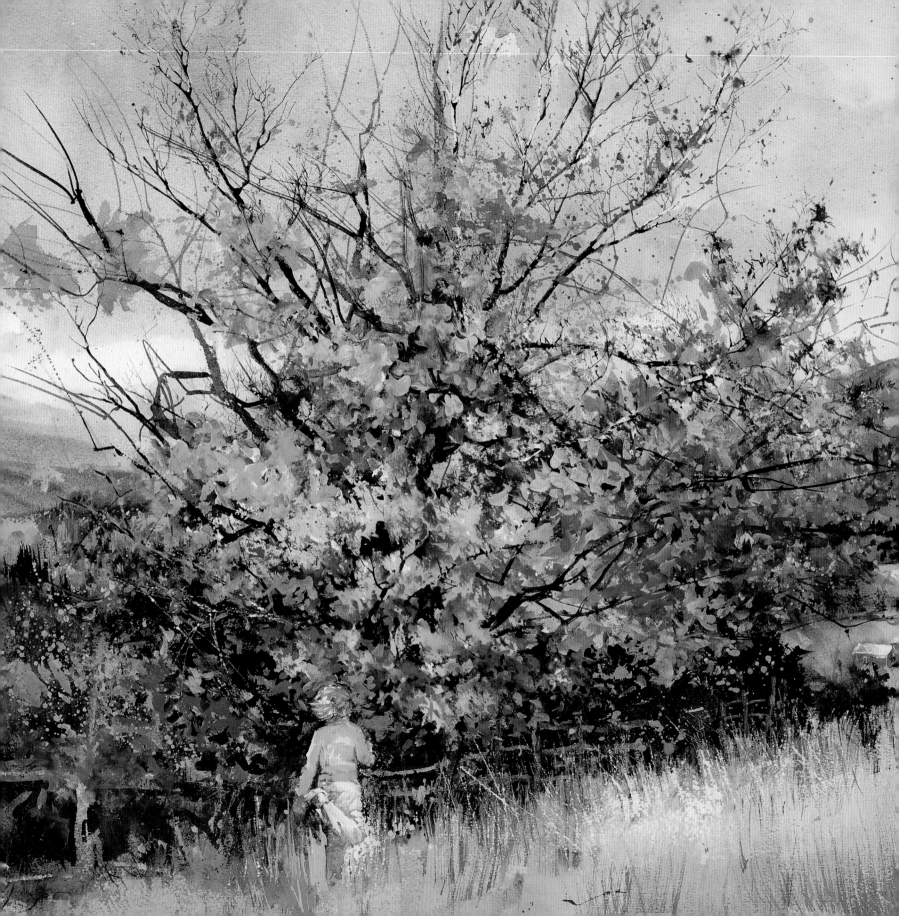

I recall our small daughter, pail in hand, walking through the forest to the spring to draw water. Right now, I can see the pine needle path glistening in the dappled light. I can hear the chickadee chirping from a birch branch, causing my child to pause and look around. She does not know that she left soft footsteps imprinted on a mother's watching heart.

• • •

It was forty years ago. I could paint that picture today. That special moment in time lingers like a door left ajar. As I paint from memory, the door swings wide and I walk through.

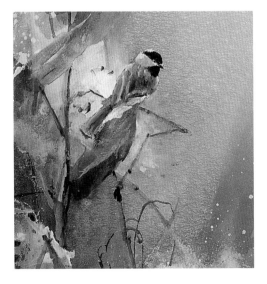

"Every child comes with the message that God is not yet discouraged of man."

RABINDRANATH TAGORE

77

Memory is a precious gift, but wonder abounds also in the here and now.
It is easy to overlook it. It's too ordinary, too familiar, and we're too busy. That
beech tree in the backyard? I pass it every day. I rush right by. But wait!
The late afternoon sun is turning the leaves gold. Purple shadows are
collecting around the trunk. What if I lie down on the grass and look up
through the branches at the mosaic of chips and pieces of sky? What if I climb up
into the tree and look down? Half a dozen paintings suggest themselves. I could
travel no farther than my backyard and never run out of subject matter.

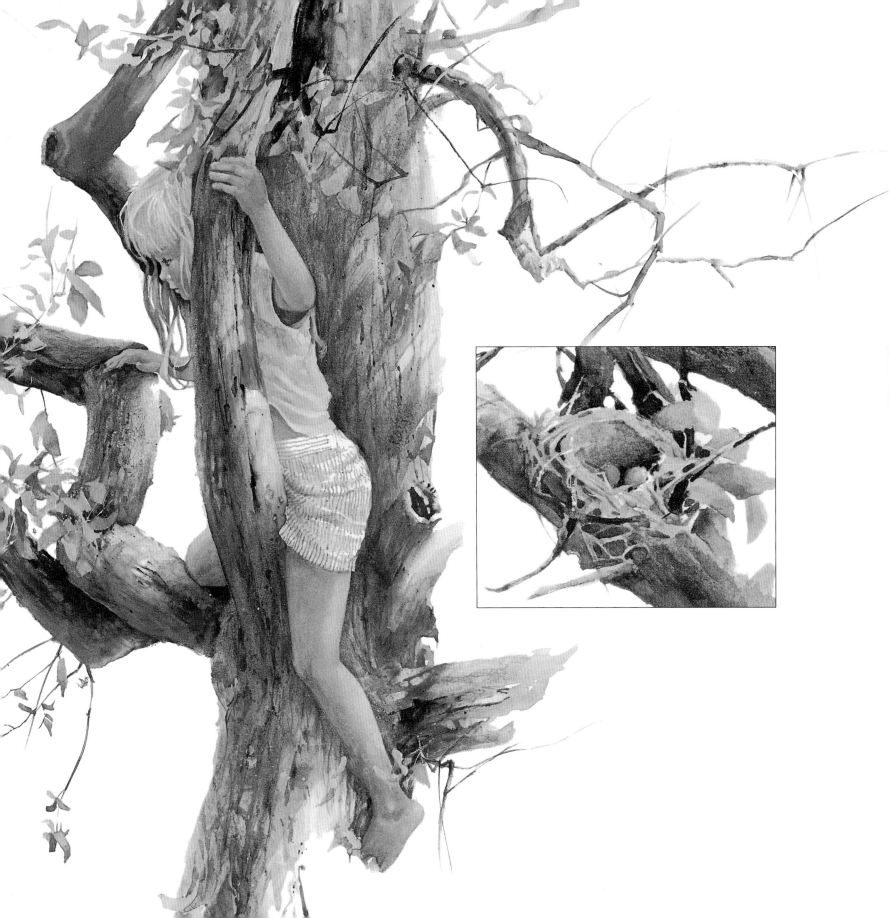

In painting a flower, I explore everything about it—petals, leaves, stem, the patterns they create. I look for the spirit the flower seems to express—wild, innocent, carefree, bold. When I paint a child, I try to see beyond facial features and find the real life within. So we talk, we play together, I watch the way the child pushes a toy car, cuddles a doll, looks out the window.

• • •

We are all God's subjects, and no one knows us so completely.

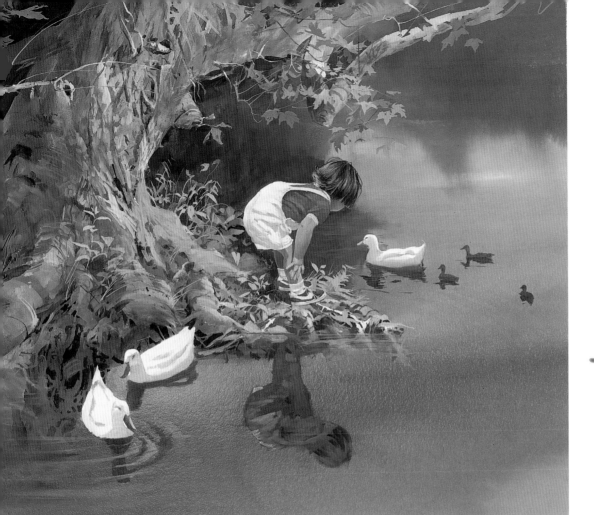

"He is like a tree planted
by streams of water,
that yields its fruit in its season,
and its leaf does not wither.
In all that he does, he prospers."

PSALMS 1: 3

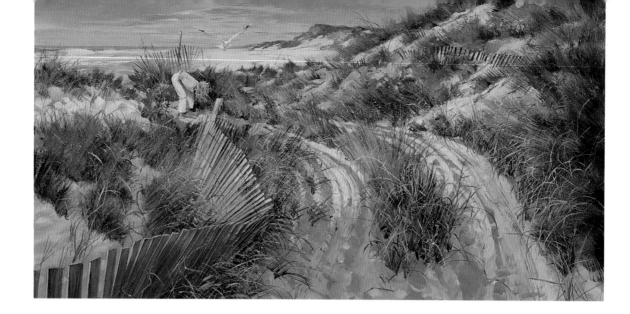

"Here or there you may witness a
startling harmony where you say, 'This will be
haunting me a long time with a loveliness
I hope to understand better.'"

CARL SANDBURG

Time has been likened to a thief stealing beauty, but true
beauty is a thing apart from time. The wear and tear of age change
but cannot defeat it. Take a sand fence. New, it was straight and rigid,
boring in design. But as it ages, there is movement through it, a tracing
of its life experience. The pickets become notes, each a little
different, giving the fence a windswept song to sing.

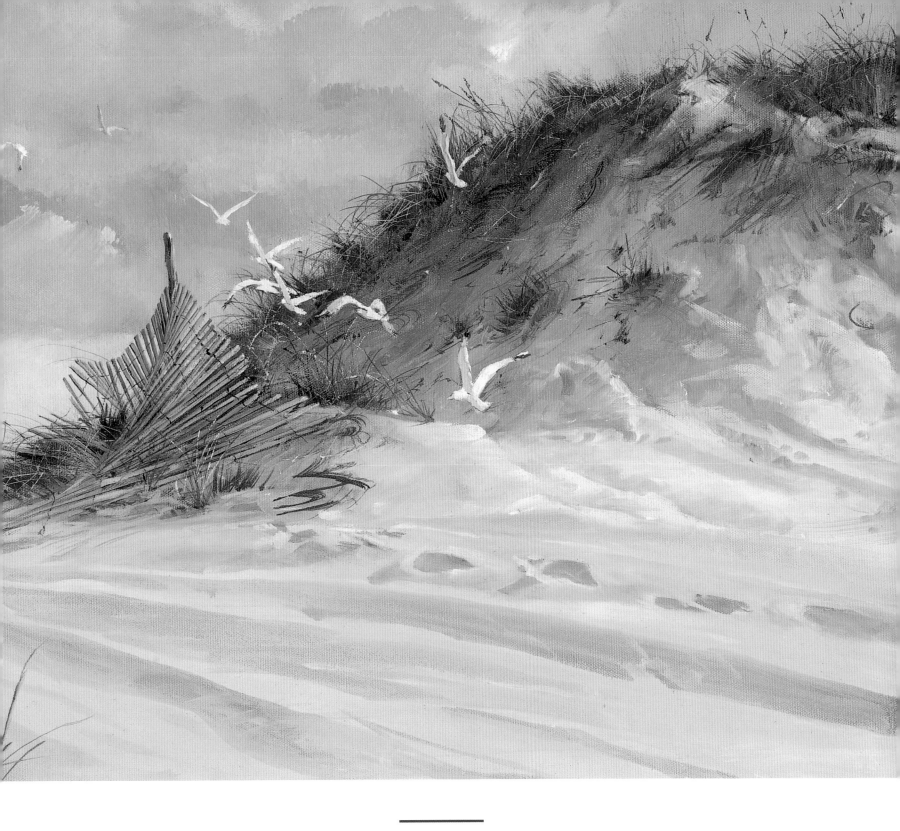

In life and art,
it is important to see
beyond appearances,
to approach things
from various
perspectives, to be
open to every nuance
of the universe,
attuned to every
whisper of God.

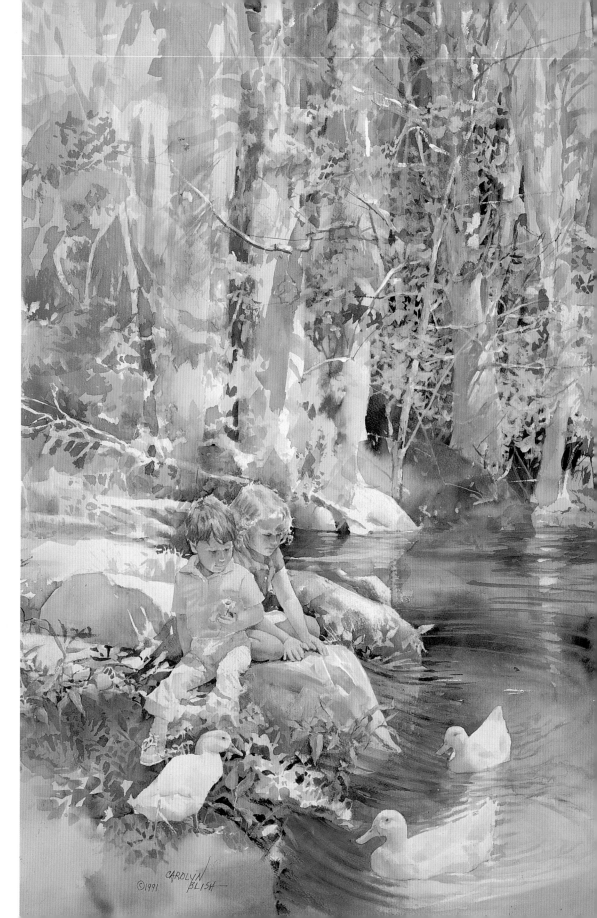

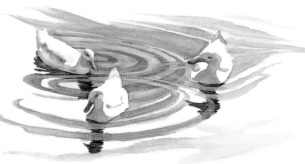

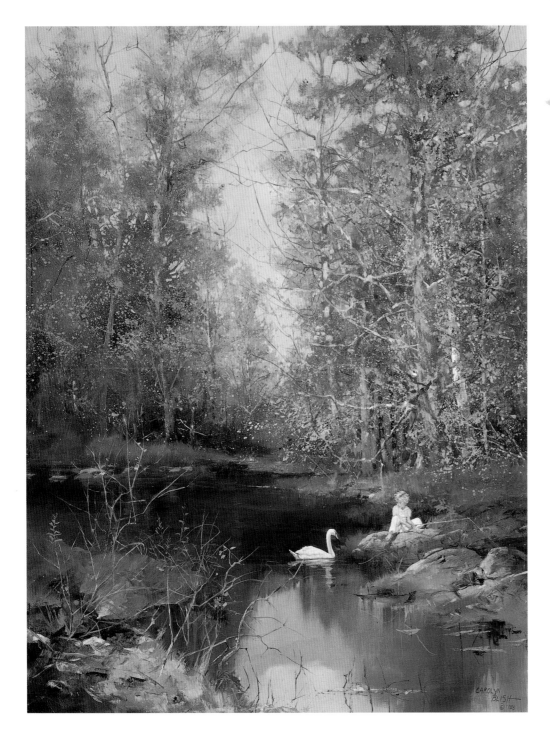

Dare to approach, absorb,

be immersed,

surrounded,

enlivened,

enveloped

in all the miraculous

elemental stuff of life:

earth,

sky,

sea.

Be renewed,

refreshed,

replenished

by the treasure

of God's unsurpassed,

inexhaustible

beauty.

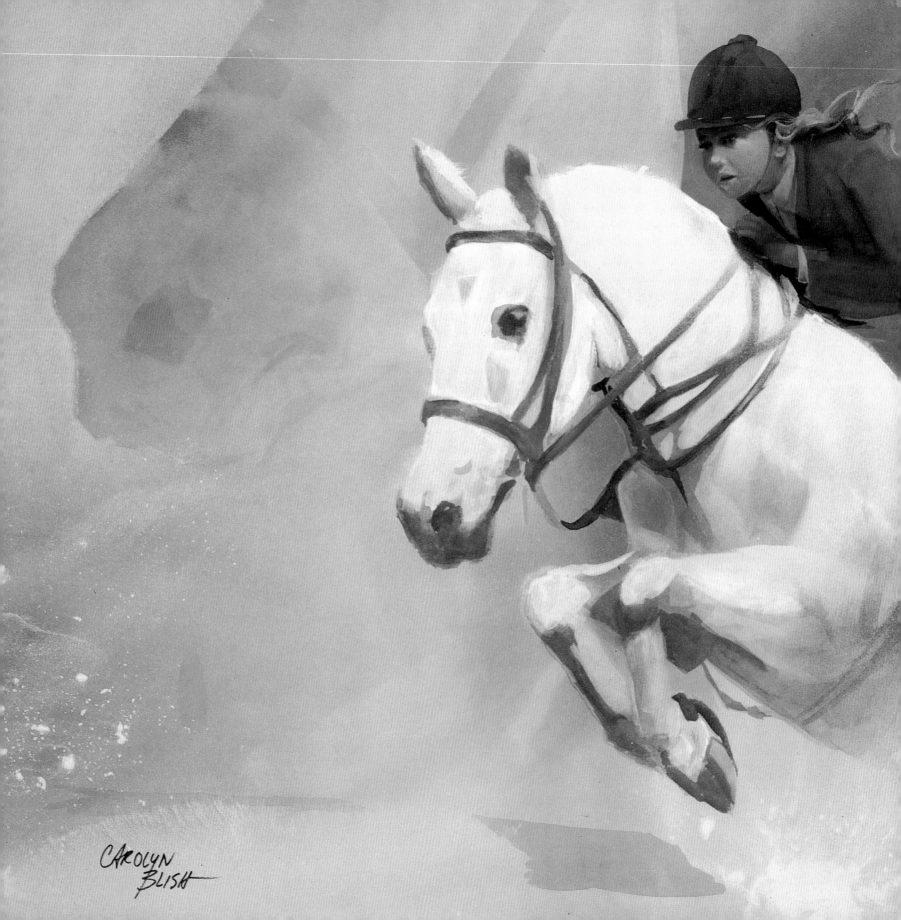

CAROLYN
BLISH

Brush Stroke by Brush Stroke

Brush Stroke
by
Brush Stroke

"If our lives are to show
the love of God,
we cannot do
it without the
God we love."

JILL BRISCOE

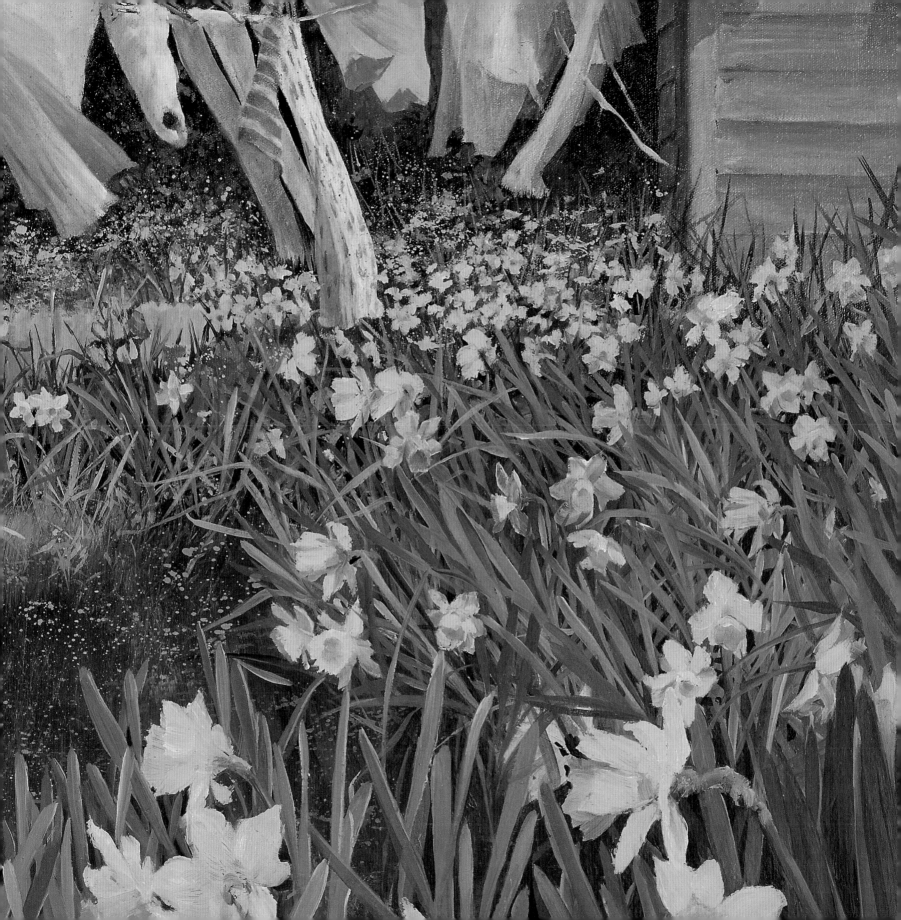

Years ago, our little granddaughter visited us, and she decided she wanted to paint a picture of herself. So I set her up in my studio with paint, paper and brush. I asked if she would like me to help. But she wanted to do it on her own.

"Watch!" she said, self-confidently. So I stood behind her and watched. She began exuberantly, but it wasn't long before disappointment set in; then discouragement; then despair. "Oh, Grammy," she cried, "it doesn't even look like me. It's a mess."

"Would you like me to help?"

She nodded and held out her brush.

"No," I said, "keep on painting. Don't quit." I reached for my own brush and, leaning over her, started painting on her picture, adding strokes to hers. Together, stroke by stroke, we painted a portrait that turned out to look just like her.

• • •

The brush strokes we make on the canvas of life reflect our responses to circumstances and conditions.

Some of our strokes may be strong and bold, blazing forth for all to see. Others may be no more than faint traces of deeply hidden thoughts and feelings. But every brush stroke contributes to the portrait we are painting— a portrait of our innermost self, our character, our soul, the unsee-able part of us known only to God.

• • •

Our circumstances and conditions do not determine whether the portrait we are painting will be cramped and dark or flooded with color or light. What matters is whether, in joy or pain, we turn to God or away from him.

• • •

Of course, we will make mistakes, fail to achieve our goals, occasionally make a royal mess of things. But even our false moves need not defeat us, for at every moment God stands ready to help, to straighten a crooked line, to correct our perspective, to show us a way or, when we're really flounder-ing, to add a few brushstrokes the way I did for my granddaughter.

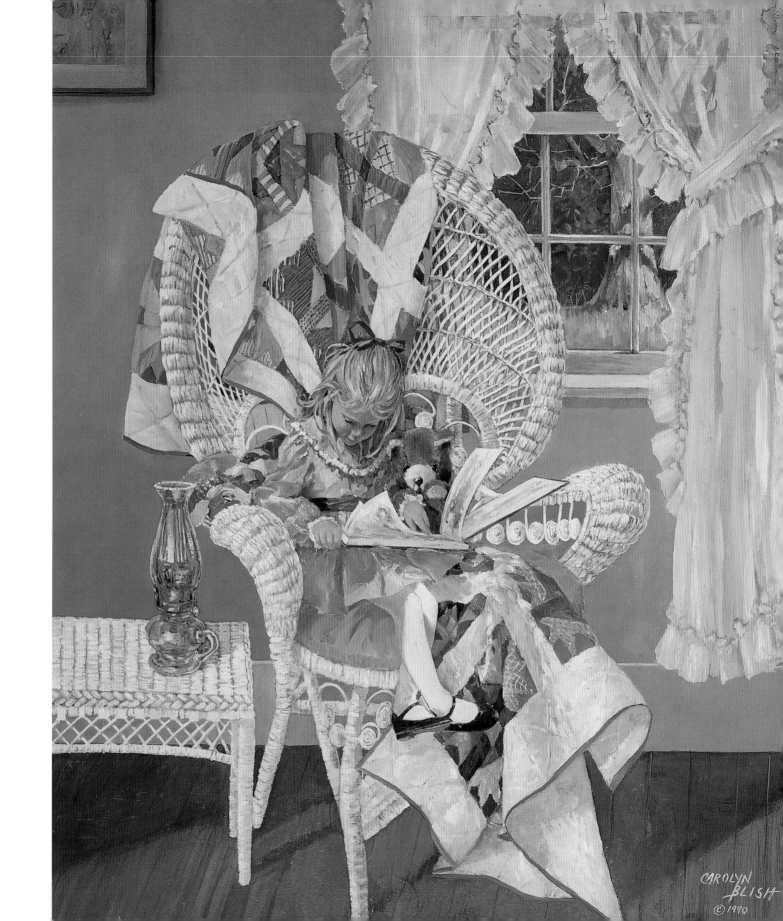

CAROLYN
BLISH
© 1990

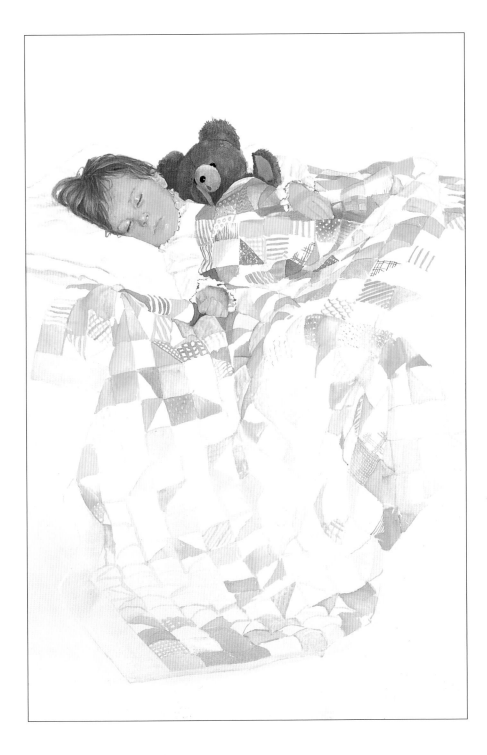

One of the things an artist has to learn is to see color. Look at a blue object. Put a red object next to it. The blue object no longer looks really blue. It has a purplish cast because of reflected light from the red object.

Therefore, the color of an object can be affected by its relationship to another object.

Purple alone is pretty, but place mint green alongside and wow—the purple becomes glorious. How purple loves green!

• • •

Sometimes we need to be a green in a purple person's life.

Once, a friend crocheted a shawl for me. She said it was "pure joy" to make it for me. It makes me happy each time I wrap it around me. It wouldn't be the same if I knew that it had been drudgery for her to make it.

• • •

Real works of art are created in joy—a demanding, exhausting kind of joy, but real joy all the same. I want to gift-wrap my joy and give it away.

• • •

A work of art does not occur by happenstance. It begins with and proceeds from a heart belief and the desire to express it. Technique enables an artist to paint, but it has no value unless the artist has something personal or heartfelt to say. It is love that makes a painting art.

"A thing of beauty is a joy forever."

JOHN KEATS

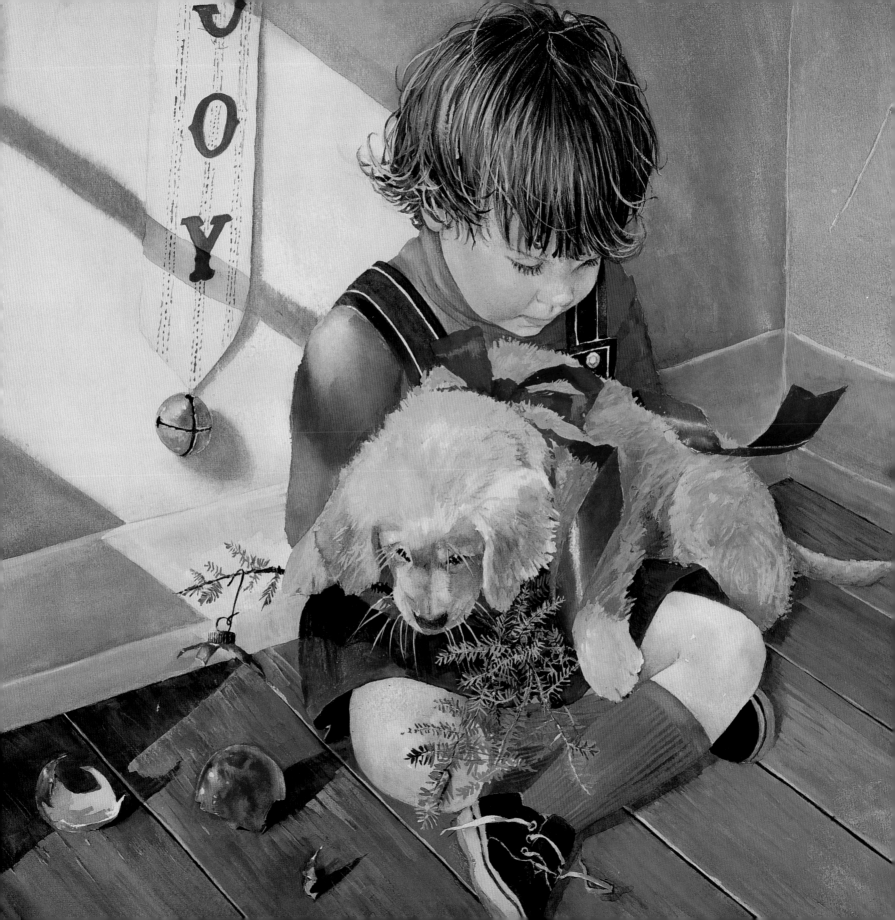

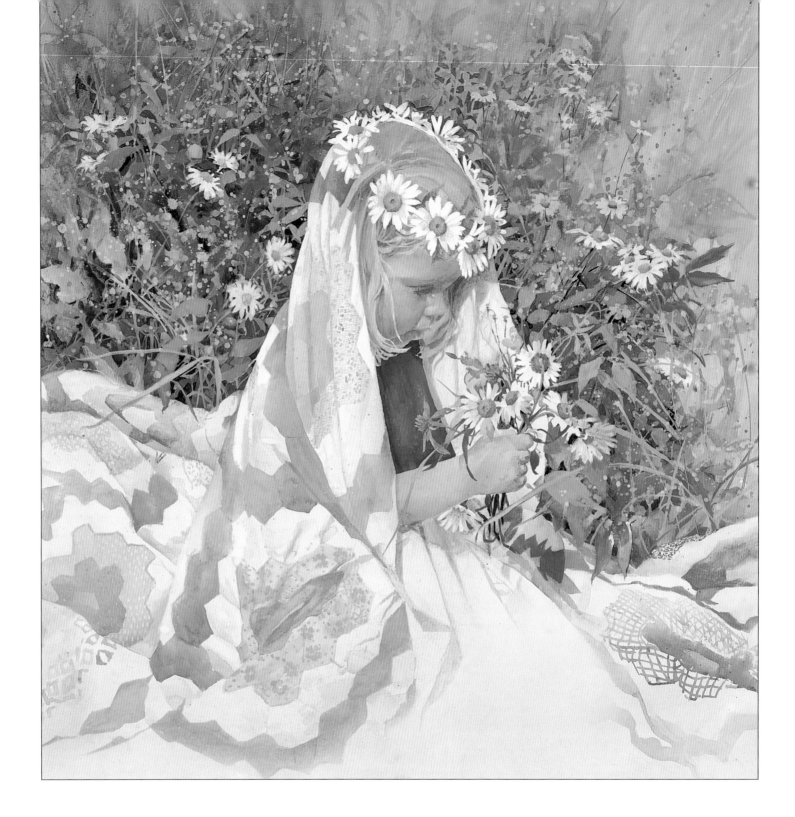

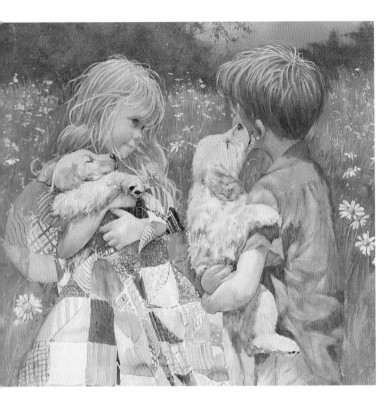

Unity is important in painting, as well. Children and daisies turn up again and again in my work because I am touched, heart-deep, by the poignant innocence of children and the clean, white freshness of a flower that I am told was once called "day's eye."

In *Daisy Queen,* I endeavored to make every element in the picture, every gesture, every detail work together to express this wide-eyed purity. The turn of the ribbon, the wisp of a blowing tendril of hair, the folds in the child's pinafore, the inter-lacing stems of the daisies relate, connect, become a chorus, hymning holy innocence—in unison.

• • •

Incongruities exist, distractions detract, but hand follows heart and faith becomes art.

"Do not be conformed to this world but be transformed...."

ROMANS 12:2

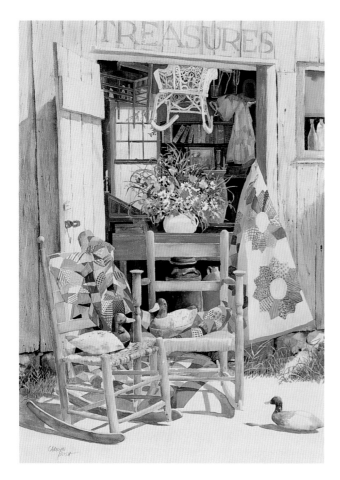

The merit of originality is integrity, not novelty. Fads come and go, and the bizarre can always be counted on for shock appeal, but an honest rendition of what is beautiful and true has power and lasting value— although it is by no means easy to do.

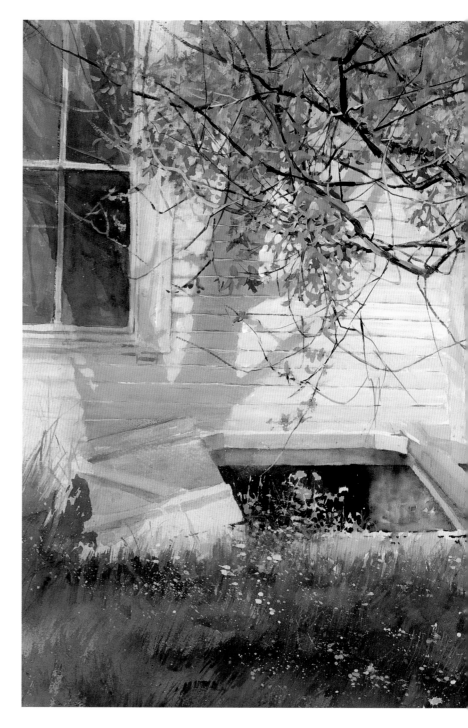

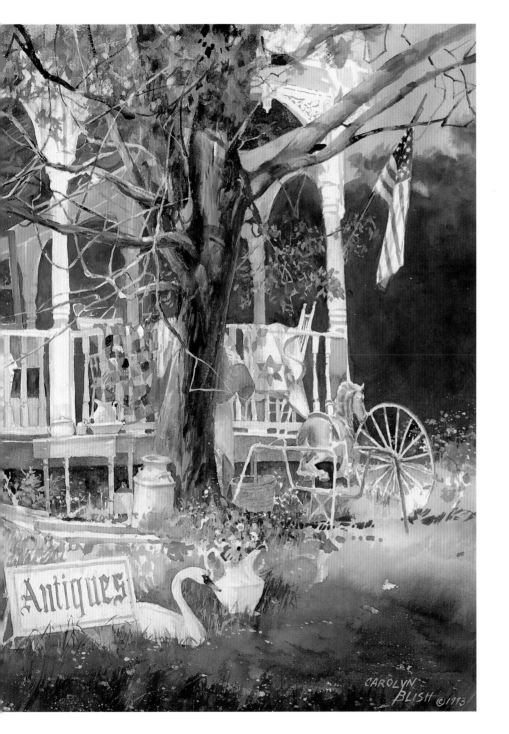

In a sense, all art is a question of relationships. Spaces look large or small in relation to other spaces. A diffuse painting can be brought into focus by the addition of a crisply defined figure.

• • •

In art, nothing happens without impinging on something else. In life, too, everything we do affects other people. For good or ill, whether we know it or not. An awesome thought. Lord, keep me from hurting someone else. Help me to help.

"...be kind to one another, tenderhearted, forgiving..."

EPHESIANS 4: 32

99

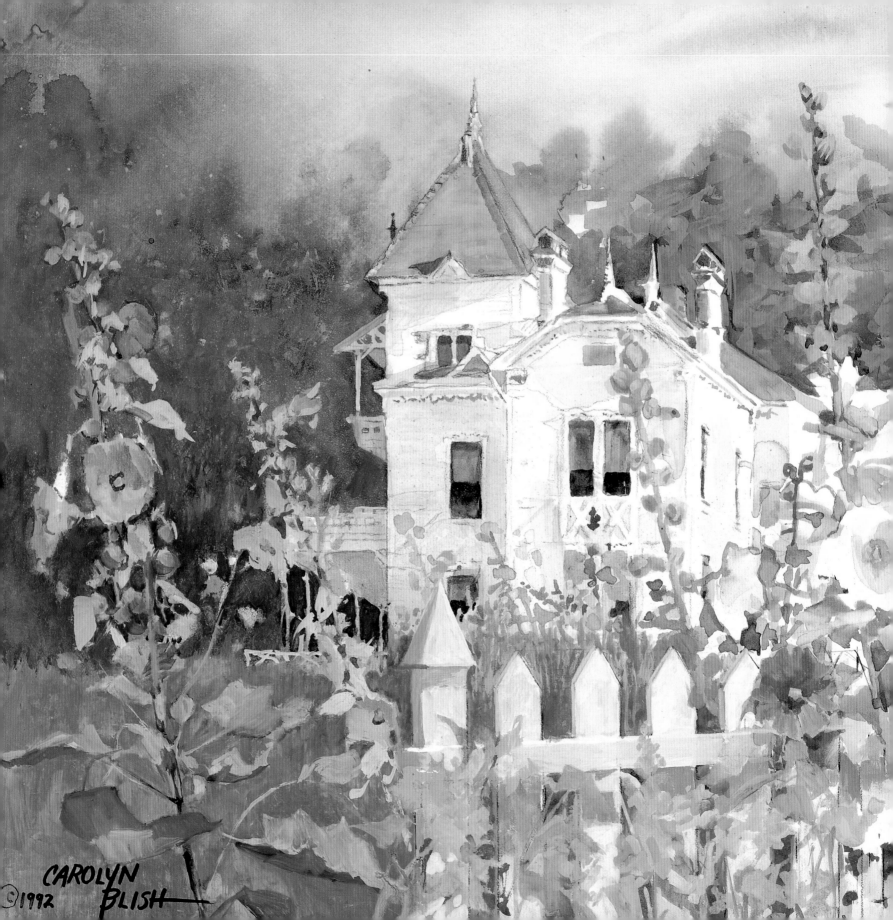

CAROLYN
BLISH
©1992

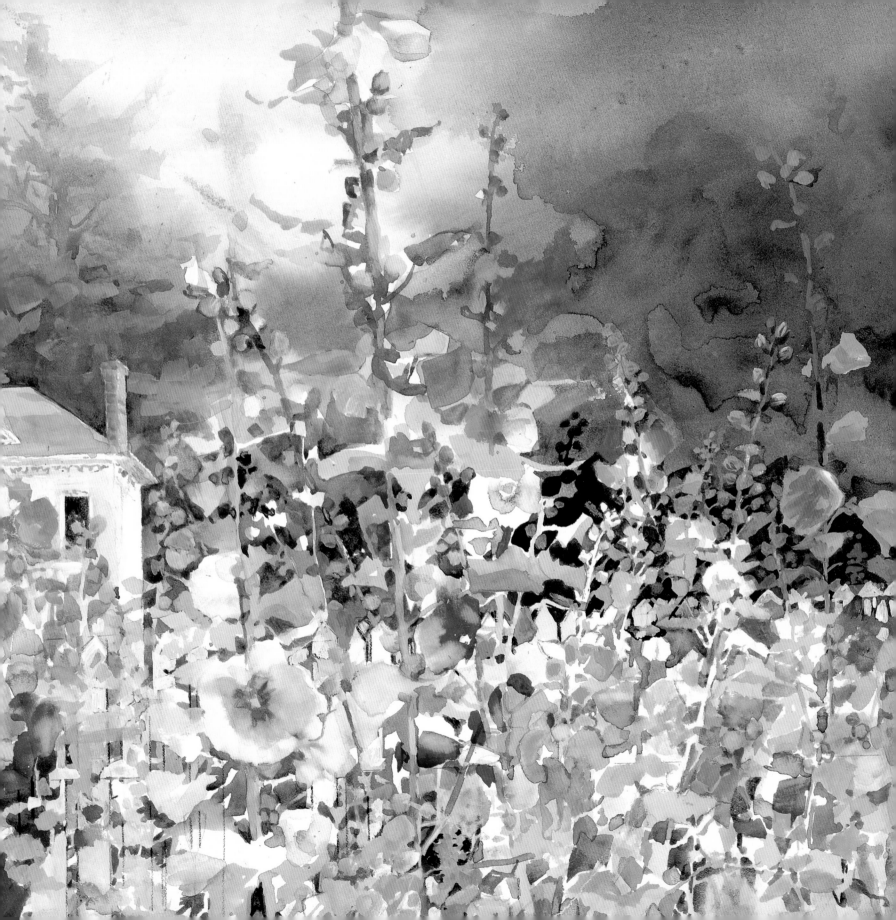

The subject I paint always has three dimen-
sions. My canvas has only two. Therefore
I can't possibly duplicate my subject;
I must translate it, catch the spirit of it.
A painting is what the artist
both sees and feels. While a
camera records everything,
I eliminate, extract, go behind the scenes
and beneath surface appearances, balancing the seen with the
unseen and always reminding myself to let no line or shape,
texture or color upstage the center of interest, the key element
that visually expresses the painting's reason for being.

• • •

I paint a landscape. It is early
evening. Everything is cast in the
sunset's golden glow—hills, houses,
trees, grass. Nothing escapes this
luminous, warm light. It washes the
world with gold. It is the most
dominant element, the painting's
heart and soul.

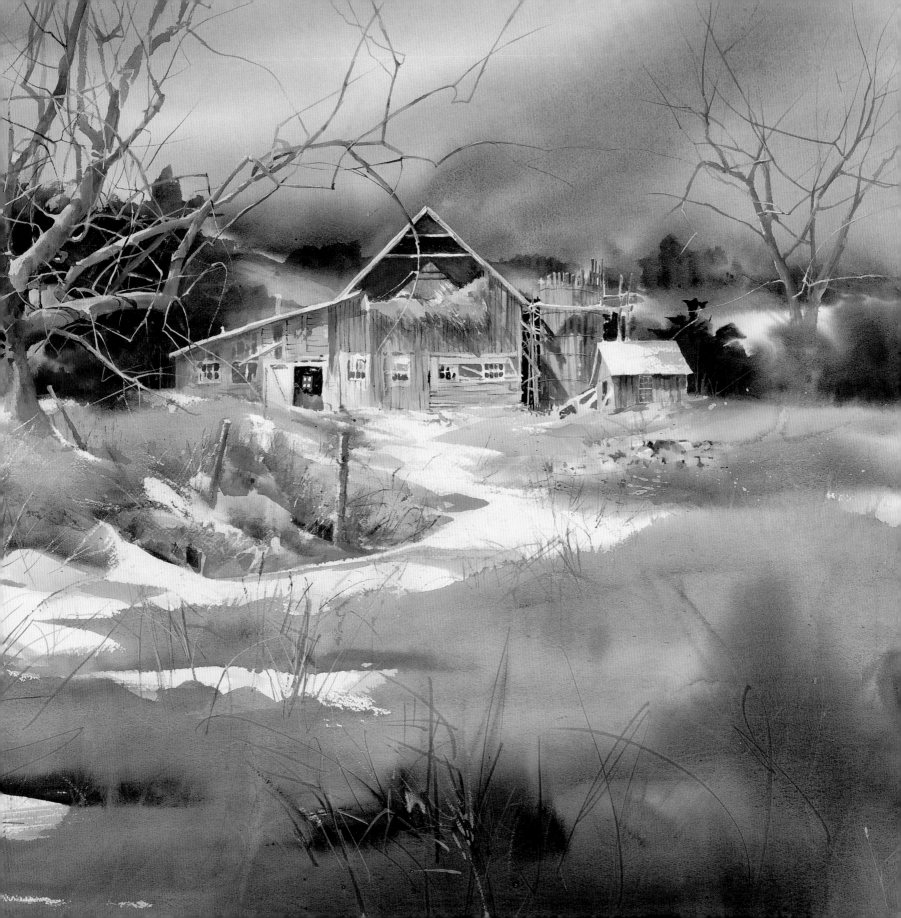

Lives, like paintings, can become too busy, cluttered and confusing. We cram our days with work, play, programs and activities. But as pleasant and useful as these may be, they fail to satisfy the longing heart. Dimly we know what we need. To simplify. To focus on the center of interest. To subordinate our transient whims and wishes to the enduring wonder of drawing closer to God.

"…Thou shalt love the Lord thy God with all thy heart, and with all thy soul, and with all thy mind…

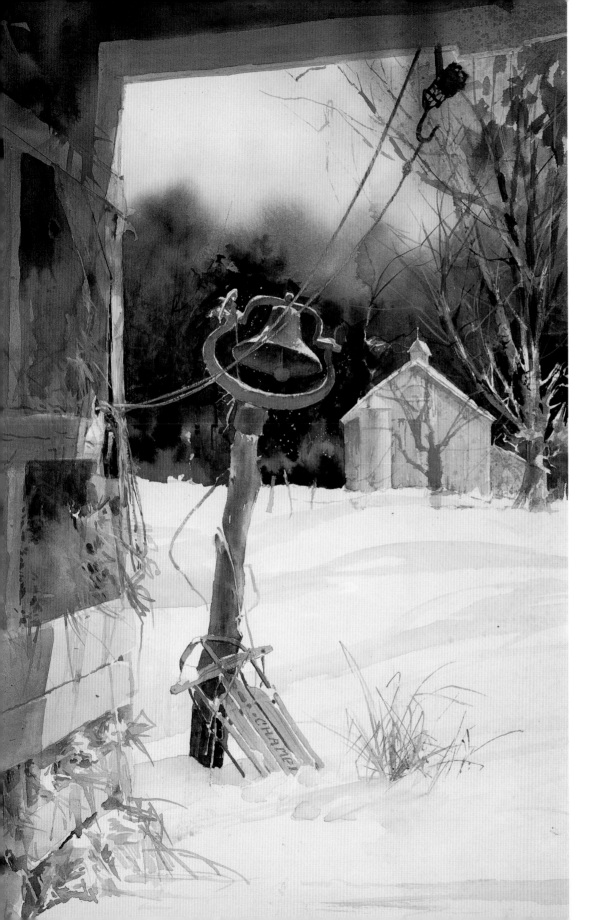

*...Thou shalt
love thy neighbor
as thyself.
On these two
commandments
hang all the
law and the
prophets.*"

<small>MATTHEW 22: 37–40</small>

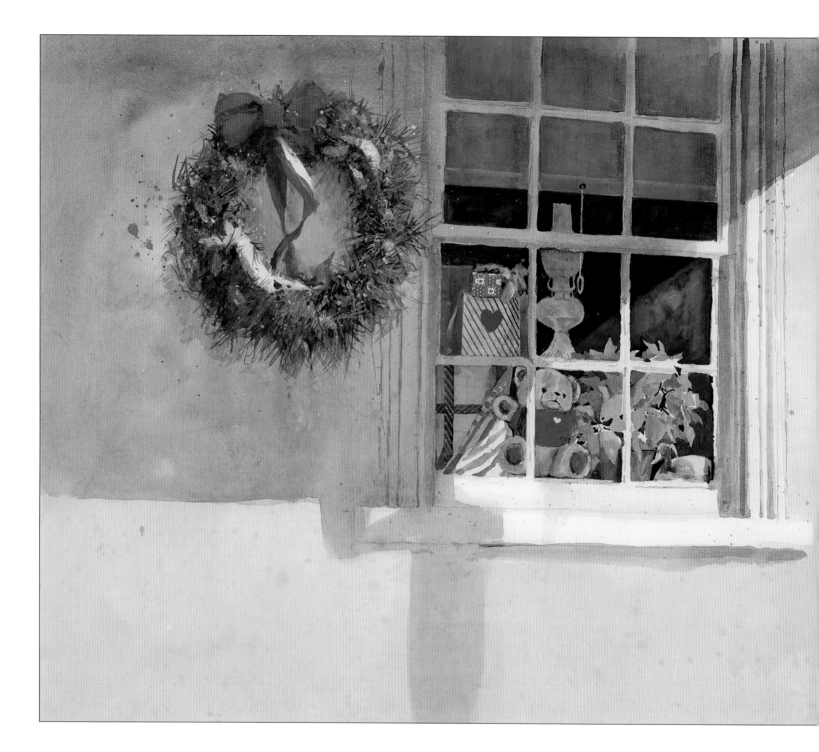

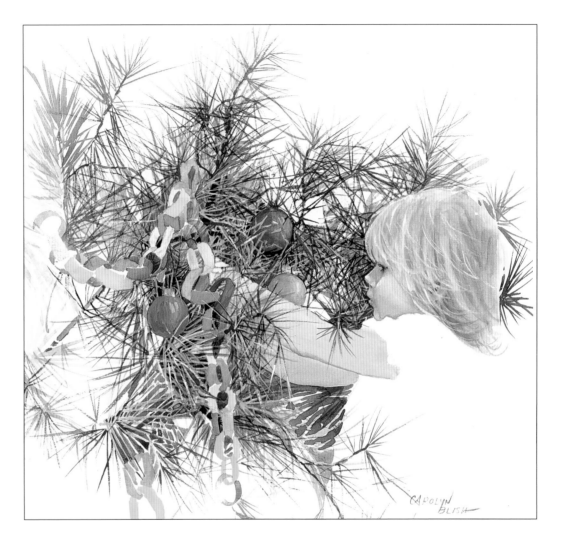

"*This is the day which the Lord has made; let us rejoice and be glad in it.*"

PSALMS 118:24

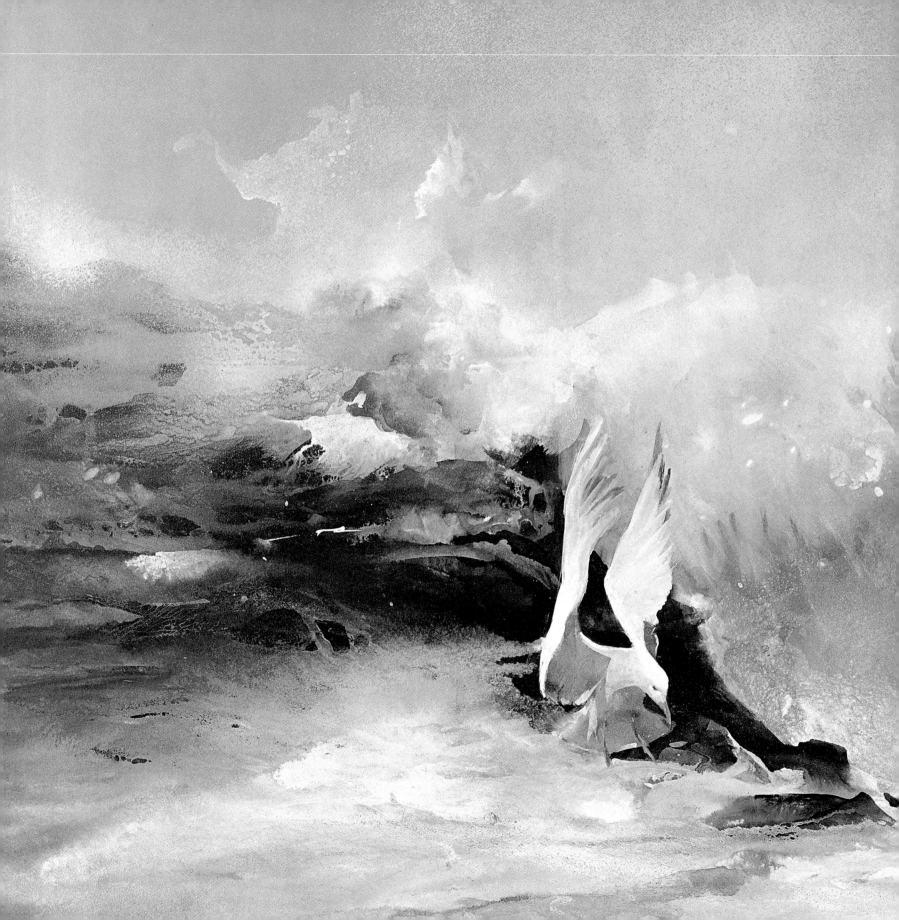

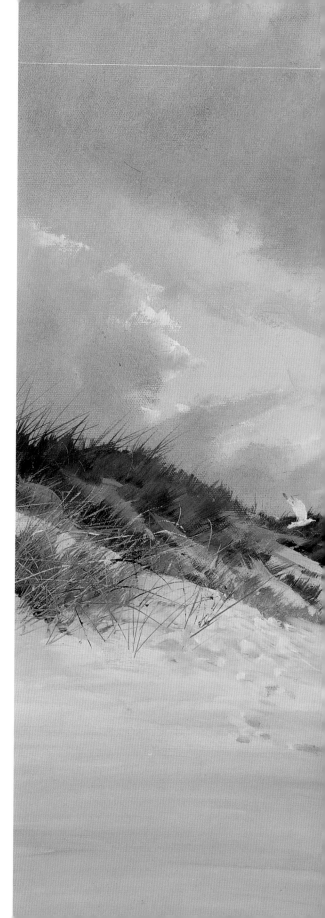

Lights and Darks

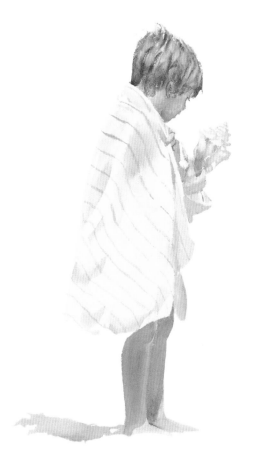

"...God is light
and in him
is no darkness
at all."

I John 1:5

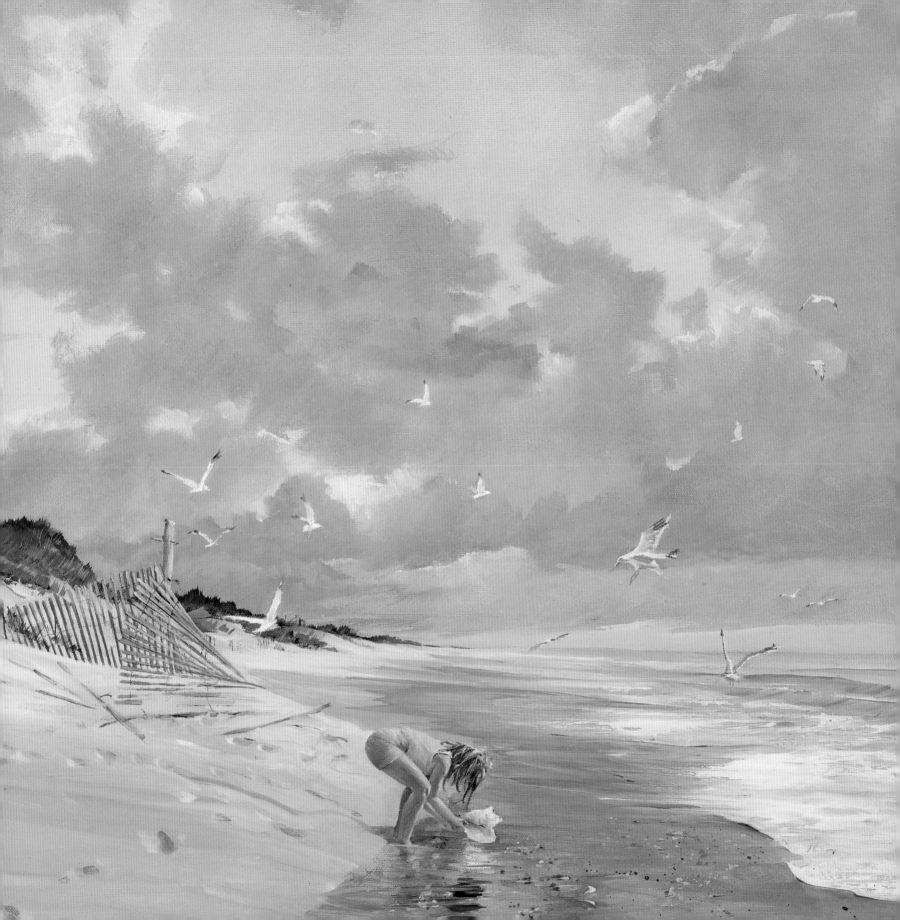

O h, the infinite variety of the Maine coast. In twenty-four hours the weather is a parade of contrasts: milky white fog swishing the long white skirts of morning; black clouds, high winds and raging seas in the afternoon; an apricot-color sunset mirrored in pink pondlike pools; visibility clear to forever. And then, the farewell of another day, moonlight brightening a pewter path to the dark mystery of the horizon. Alone each is beautiful; together they add up to total enchantment.

• • •

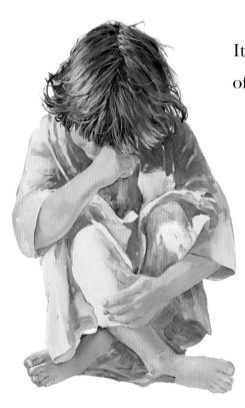

It is in times of turbulence that we imagine what we want is a life of total calm, that it would be good for us. We forget our capacity for boredom, the danger of complacency and our disinclination to learn hard lessons unless we have to, the fact that change is growth and not to grow is to die. Fortunately God knows our needs and lovingly provides. Conflict, the contrast of opposites, is the dynamic essence of art. It's a tension between dramatically different elements—a child smiling with tears on his cheeks; a raging, rolling sea hurling itself against a solid rock ledge; the black shadow

of a branch cast on a sun-drenched wall. Contrast gives life and vitality to a painting and makes life the exciting adventure that it is. When sadness and pain come, it is hard to see them in context, to imagine there could be sunshine anywhere, much less here and now, even in depression and despair. Yet God, like the sun, is omnipresent whether we realize it or not, and painting teaches me that lesson again and again. When I paint a tree, I must ask: Where is the source of light? Where will the shadow fall? The two are inextricably related. Shadows occur when something (a building, a tree, a cloud) stands between the viewer and the rays of the sun. But the source of light is unaffected by the interruption. The sun holds its course.

• • •

Sometimes we allow something we fear—cancer, poverty, old age, loneliness or death—to come between us and God, blocking out the joy of his presence. Fears like black clouds may obscure our view of God, but God is beyond the shadows, above the clouds, lighting the universe with the blazing power of his love.

"Your love, O Lord, reaches to the heavens, your faithfulness to the skies."

PSALM 36:5

"Mightier than the thunder of the great waters, mightier than the breakers of the sea— the Lord on high is mighty."

PSALM 93:4

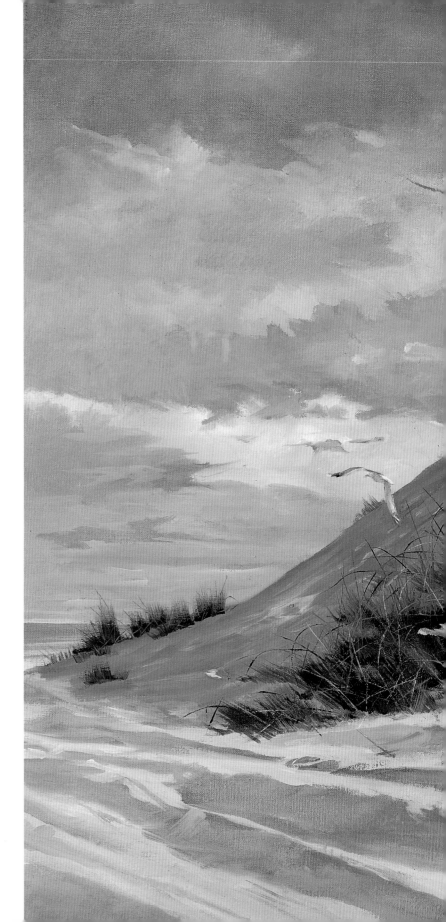

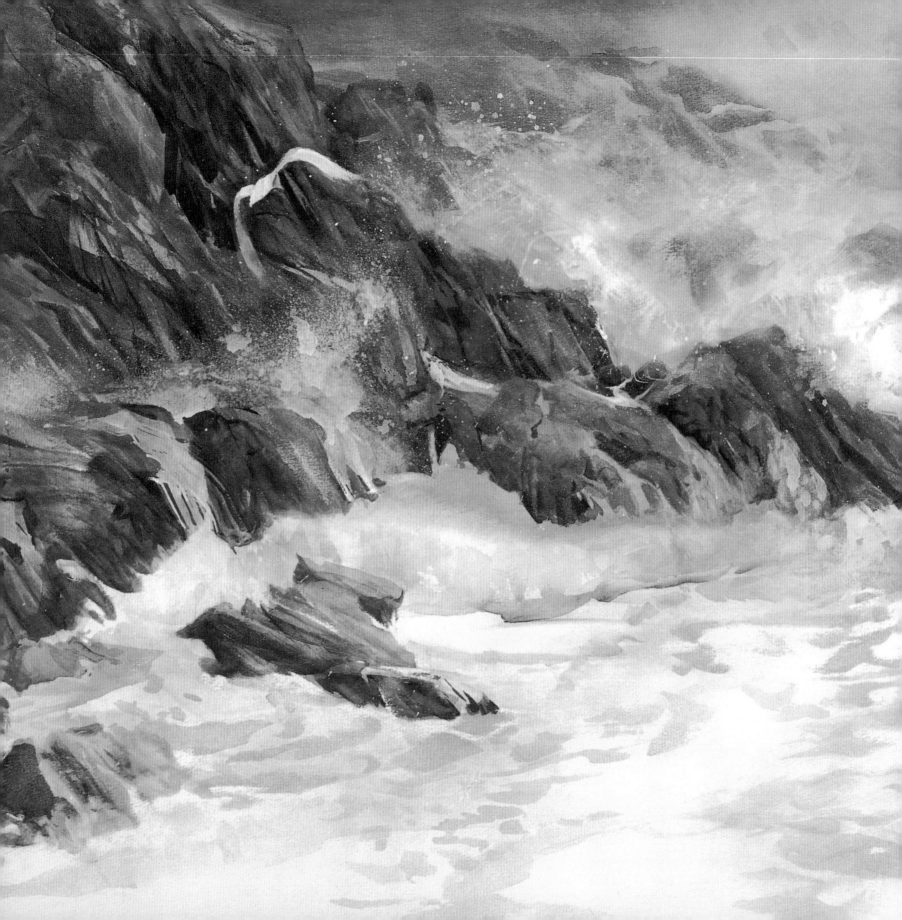

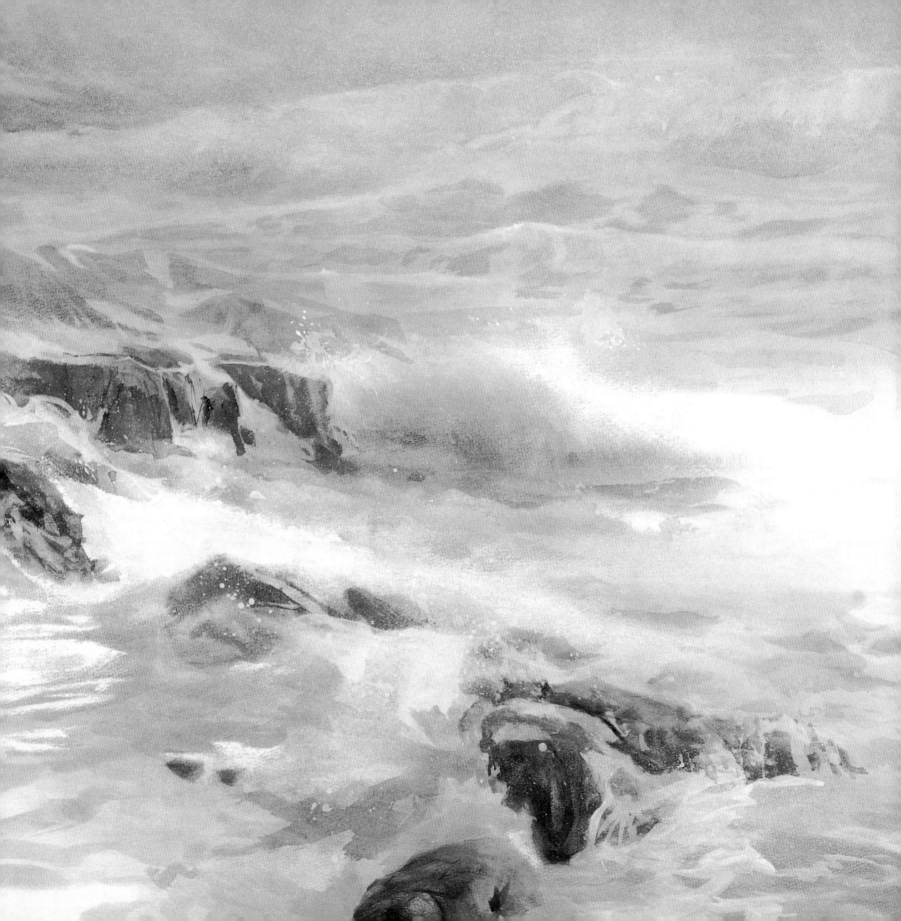

Spiritual life is composed of darks and lights. In a painting I call *Wings,* there appear to be two gulls: one light, one dark. But the dark gull-like form blending into the background is not a separate entity. It is the white gull's shadowy self. This dark shadow holds and hides loneliness, sorrows, frailties and failures, the things we fail to do, the things we should not do, our imperfect nature. This shadow is always close to us, but the choice is ours, to fly in the light or dwell in the shadow.

• • •

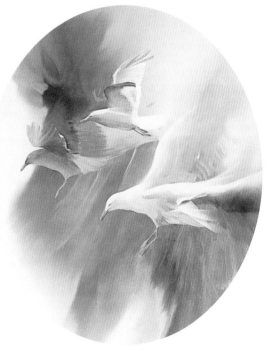

No matter how happy people appear to be, no matter how competent, successful and powerful they seem, there may be dark agonies in their souls that we may never see. And all of us have dark moments when we distrust even the thing we do best.

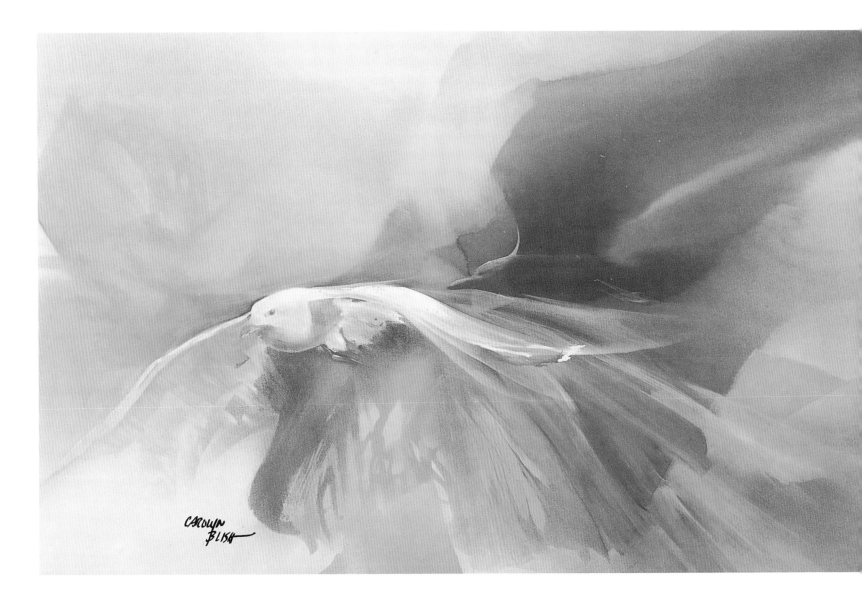

"...walk as children of light...

have no fellowship with the unfruitful works of darkness...."

 EPHESIANS 5: 8, 11

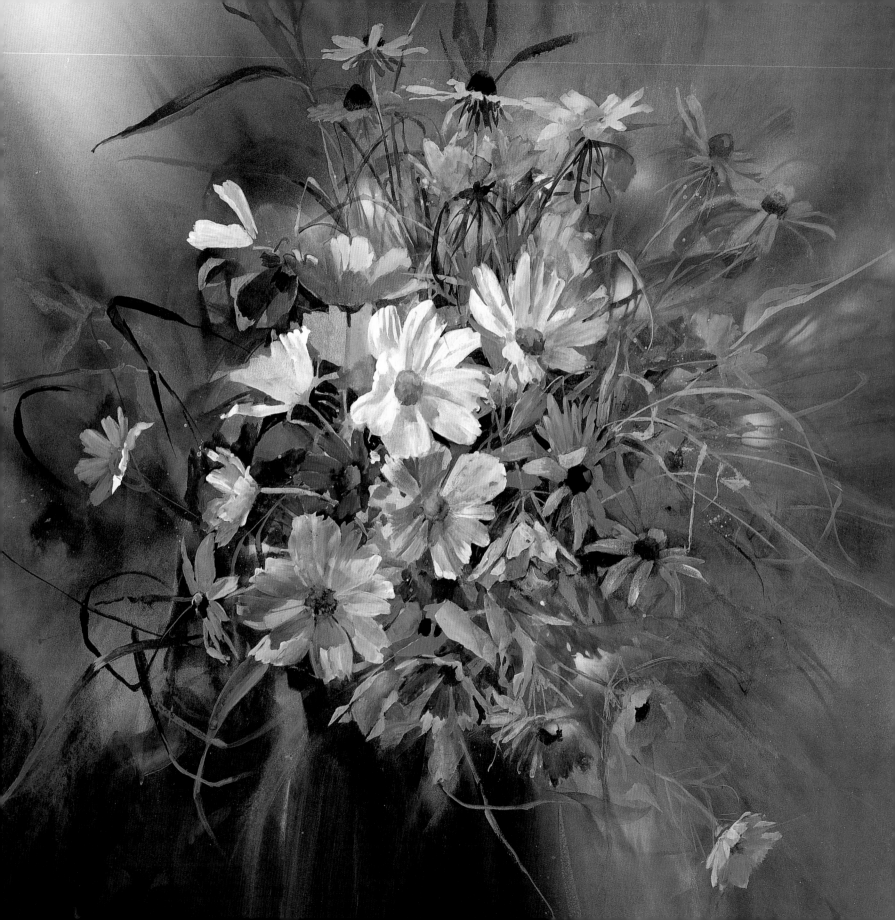

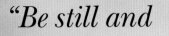

*"Be still and
know that
I am God...."*

PSALMS 46:10

I am convinced that God paints these dark passages into our lives to refine and stretch us and always brings us closer to the Light. There are precious lessons to be learned in these shadow experiences. Although they seem like endings, they are often beginnings.

• • •

Painters, in particular, are a paradoxical bunch. They are certain, yet uncertain. They are subjective and involved as the painter, yet objective and detached as the viewer. They believe in their work, but need reassurance. They think they know exactly where they are going, and then suddenly they find themselves in completely unknown territory.

I can paint happily for days and suddenly I come to a point when everything is going downhill. I look at what I have done and despair. I turn the painting upside down, sideways, look at it in the mirror, in different light in different rooms. Something is lacking, desperately needed, but I have no idea what it is.

• • •

I have collided with my limitations. There is only one thing to do. Stop, wait, rest, listen until a new surge of knowing comes. This waiting in my search for expression takes many turns. During one of these turns, I bump into my inner self and finally see what the painting needs. Like a haunting love song, the beauty that delighted and captivated me in the beginning renews its flow.

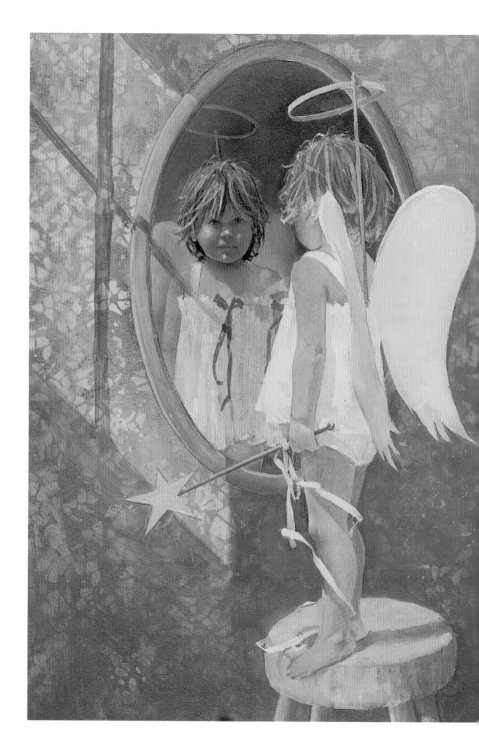

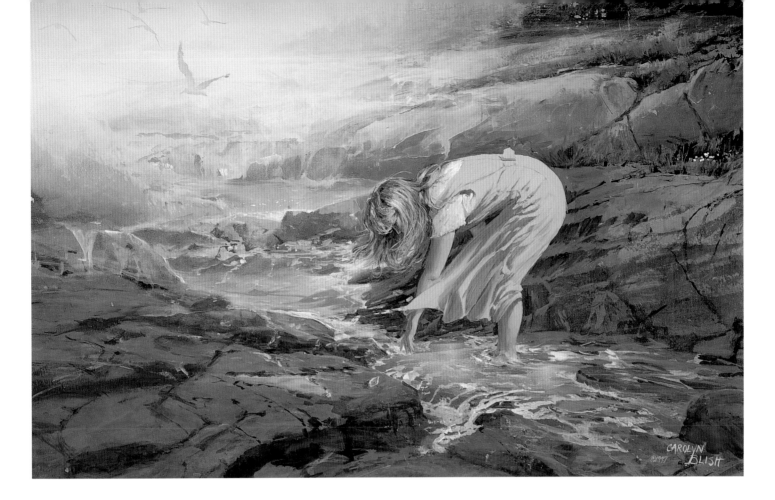

The idea that waiting can be productive takes a bit of getting used to. In America, activity, hustle-bustle and talk are admired, almost idolized. Standing on a rock ledge in front of our island home, wrapped in the vast emptiness of sea and sky, soft fog wadded from here to eternity, the only sound the calm ocean's gentle surge and the occasional cry of a gull, who will believe that I am resolving an impasse in a painting or my life?

"...in quietness and in trust shall be your strength."

ISAIAH 30:15

123

*T*roubles are so insistent it's hard not to focus on them to the exclusion of everything else. But earthly life is always a mix of contrasts—litter along the road and a majestic view of mountains beyond. As a painter, I don't have to paint the litter. As a child of God, I don't have to count my grievances to the extent that I forget my blessings. But of course, being human, I sometimes do. I remember a day on Martha's Vineyard when I decided to paint gulls.

"The dump," my husband said. "There are more gulls at the dump than anywhere else." We drove to the dump; I jumped out, and Stan drove off to do errands in town. "Don't hurry," I cried, envisioning a long, lovely morning painting seagulls.

But there were no gulls. There was only rusting metal and rotting produce. I sat down on a broken wooden box, annoyed, glum, disappointed, staring at the ground. My mood was so bleak that it was quite a while before I noticed, inches from my right foot, a beautiful Queen Anne's lace plant. I examined the largest flower up close. How intricately it was made! How each tiny flowerlet fitted together to form a spiritual whole. I picked up my brush and began to paint Queen Anne's lace flowers against a blue sky. The dump was still all around me, but I no longer saw it. I was immersed in beauty.

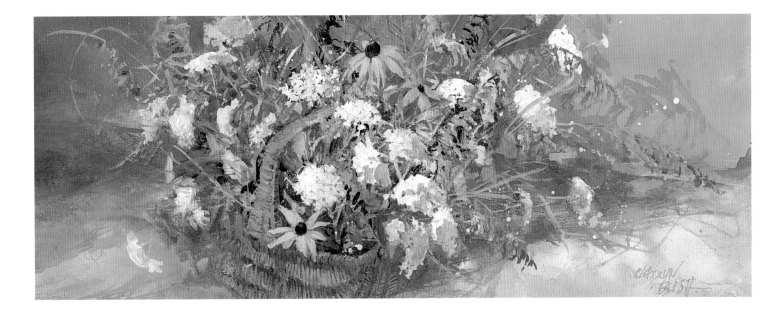

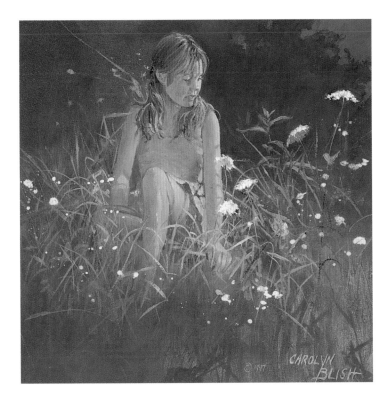

"...*whatever is true,*

whatever is honorable,

whatever is just,

whatever is pure,

whatever is lovely,

whatever is gracious...

think about these things."

Philippians 4: 8

125

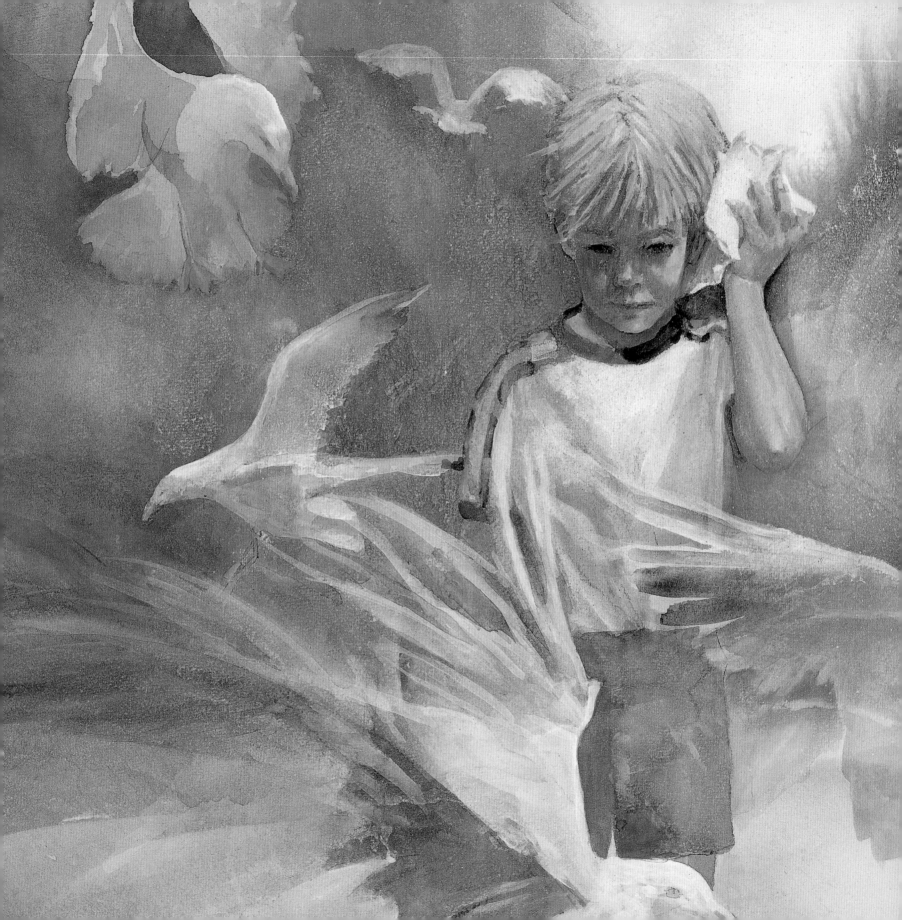

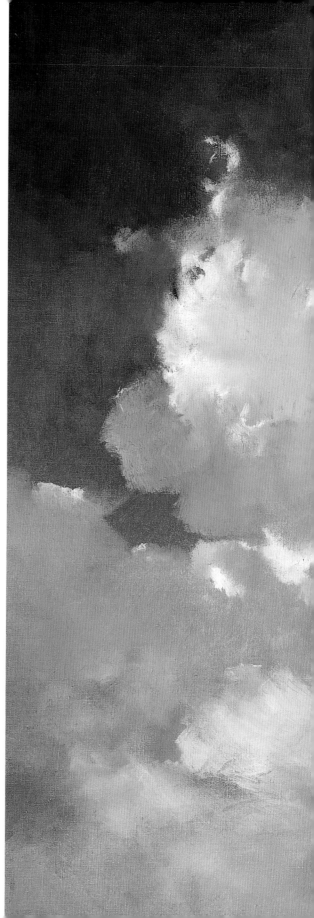

With Wings as Eagles

"...they that wait upon the Lord
shall renew their strength;
they shall
mount up
with wings
as eagles..."

ISAIAH 40: 31

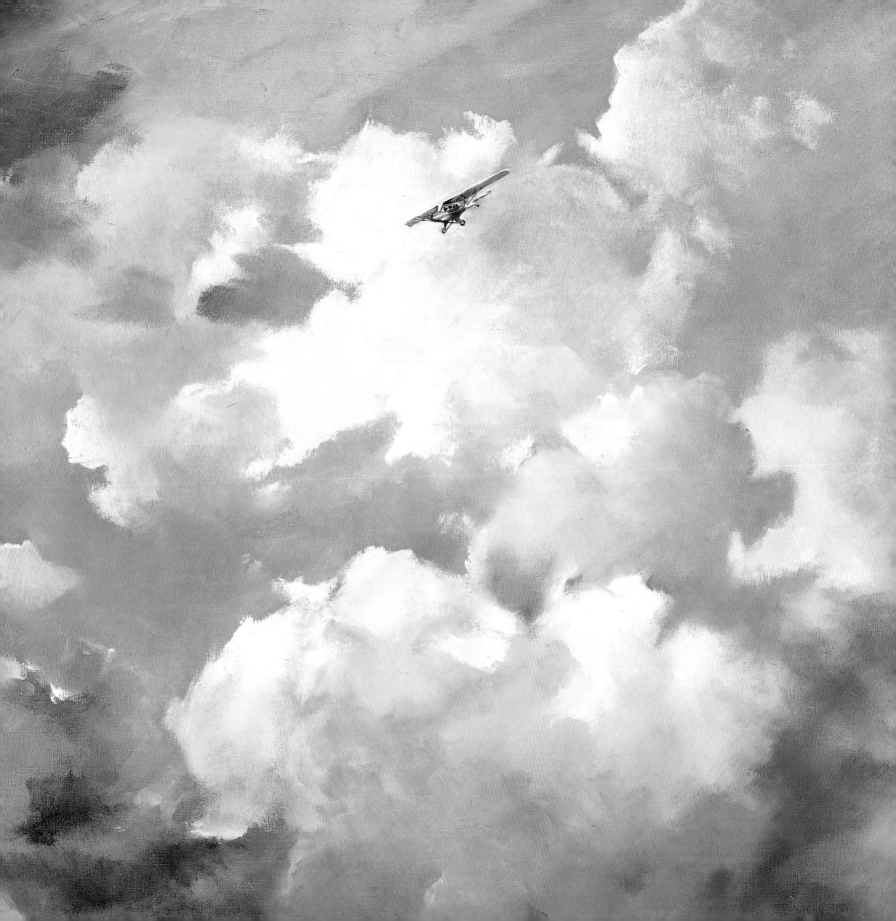

I was thirty with two young children when I noticed my husband looking at the sky with longing eyes. Aviation magazines appeared in the living room. I realized that Stan had never given up his dream of flying. As a youngster, he would labor for days building delicate model airplanes in order to launch them from the roof of an apartment building for a few delicious minutes of flight before they crashed to the cement sidewalk below. His lost labor was unimportant. The joy of the flight was all. He would gather the splintered balsa and ripped tissue for another dream flight to come.

• • •

With determination, Stan achieved his goal. A skillful pilot with over four thousand hours of commercial and instrument flight, he eventually owned his own aircraft. I loved flying with him, watching his competent hands at the controls and soaring high above the earth. Then Stan gave me a newspaper clipping about a man who had a heart attack while piloting a plane. His wife, sitting next to him, did not know

how to fly, but the control tower managed to talk her
back to the airstrip where she crash-landed. They did get
the husband to the hospital in time, but it was a close call.

"I come from a long line of heart attacks," Stan said.

I couldn't believe my ears. He was saying that he thought
I should learn to fly. Well, I thought I should learn to fly, too.
But I wondered how. I wasn't mechanical, knew nothing about
navigation and was anything but a daredevil—I was the last kid
on the block to learn to ride a bike.

• • •

When I arrived at the airfield for my first lesson, I was sure the plane was too
small. The instructor was too young. I reminded myself that hundreds of
people had learned to fly, and for my husband's safety, my own, and for our
two young children at home, it was important for me to learn, too. I told my-
self that and I believed it, but I remained rooted to the spot.

"Look, lady," the instructor said. "Are you getting in this plane with
me or not?" I took a deep breath, put myself in God's hands and followed
my instructor into the plane.

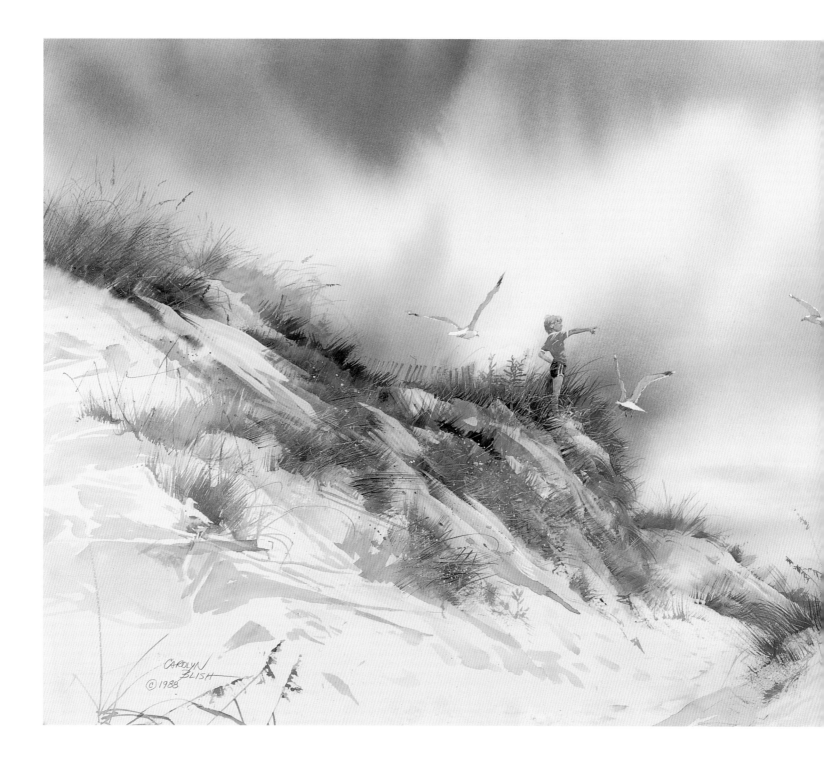

Trust was what I needed that day. Trust demands a decision, and a decision requires action. It has nothing to do with the intellect. I could believe with all my mind that the plane could fly, that the instructor was competent, but that wouldn't get me off the ground. I had to act on what I believed.

• • •

When I did, I learned to fly. Not quickly or easily, but I got my pilot's license, and it gave me enormous satisfaction to know that I had conquered my fears and was able to actively participate in an activity that gave my husband great joy. I discovered that I loved to fly as much as Stan did, and we spent many years happily cruising the blue. The big step was the first one, letting go and relying on faith and trust alone.

• • •

Committing a life to God is that easy and that hard. Christ calls us to come to him, to follow him; tells us he is the way. But knowing about him is not enough. We remain earthbound until we actively turn our lives over to him—a gigantic leap of faith, the prelude to high flight. On our own we can fly only so high. With God, the sky's never the limit.

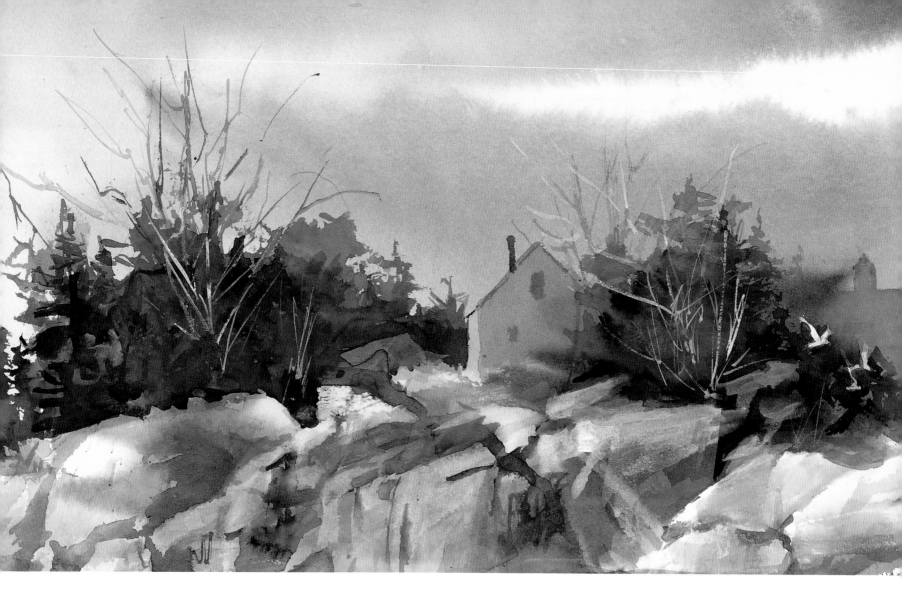

There is always a great temptation to play it safe; choose the easy, familiar, least challenging path. But more often than not, that path leads nowhere. It takes courage to climb out of the worn-down rut of mere existence, to rise above habit and timidity, to struggle in the rarefied air of creativity to fashion something genuine and original. But in doing so, we approach the Most High. To bring something new, beautiful, unique and ours into the lives of others is a godlike activity.

134

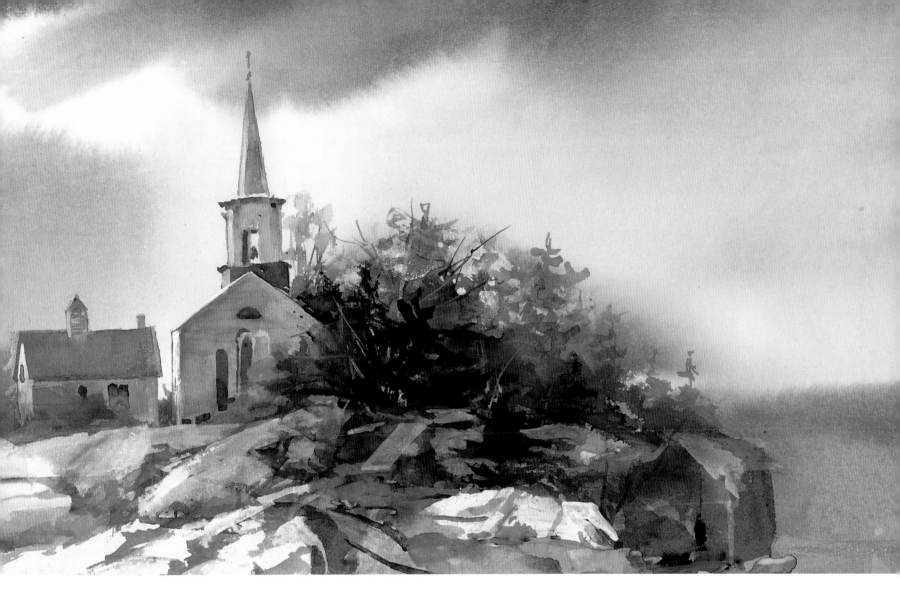

There was a time when I thought that painting had nothing to do with God.
Now I feel my painting drawing me closer to him. The art principles that govern
painting and the biblical principles that govern a godly life have many parallels, and
painting reveals them to me. It's an exciting process. Instead of being a monologue,
my painting is a dialogue. It may be that to some extent, I still paint for success,
but it is success of a different kind, one that eludes description.

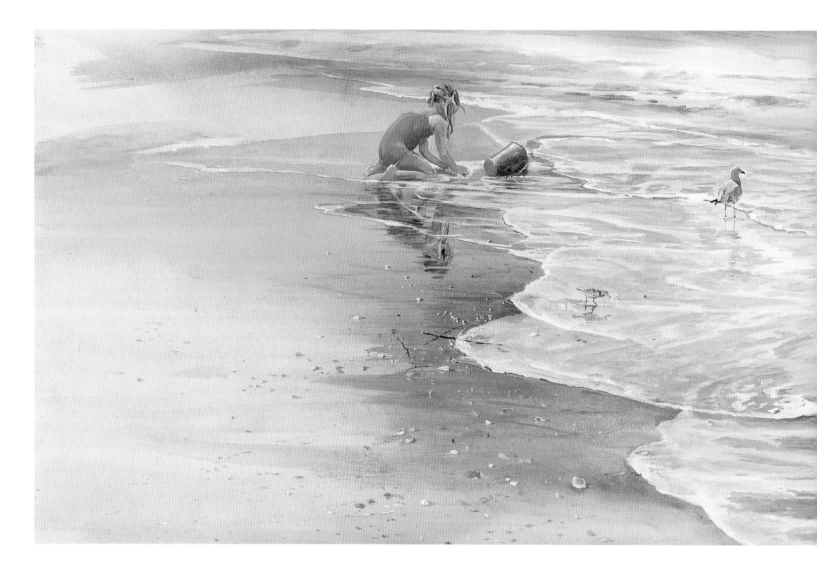

Achievement, fulfillment, sharing? I only know that when I enter my studio, I rush toward the work I am going to do. Painting is like a best friend waiting to be hugged. I love the smell of paint, the flow of color, the feel of the brush in my hand. All that matters is the pure, dazzling pigment spreading in a kind of eye music, a visible counterpart to Scriptures whispering across my heart.

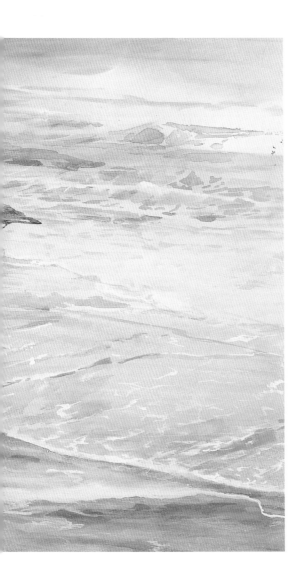

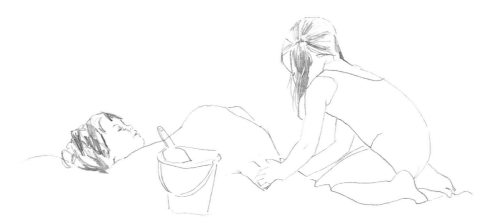

*"How precious to me
are your thoughts, O God!
How vast is the sum of them!
Were I to count them,
they would outnumber
the grains of sand...."*

Psalms 139:17–18

137

Difficulties become challenges and I run to meet them, the way I did when I was a child climbing the sand dunes near my home. There was always the irresistible urge to conquer those dunes. I can remember scrambling my way up the sliding, warm slopes toward higher ground. There is always going to be that dune challenge in our lives. God's grace always calls us higher. We can be sure the call will come when we are settled in for a snooze in the sun, perfectly satisfied with the view from the bottom of the dune. But we can't stay where we are and go with God. Stepping out in obedience to his call is our special ordained moment of truth.

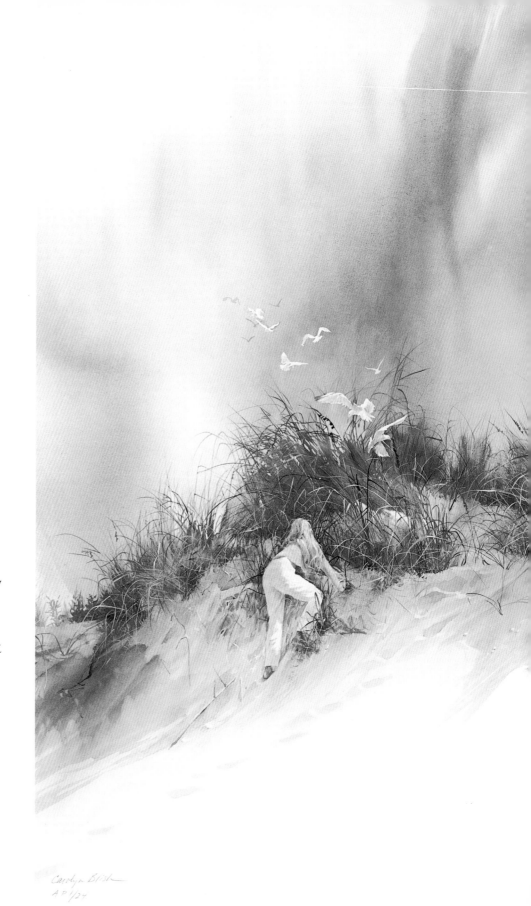

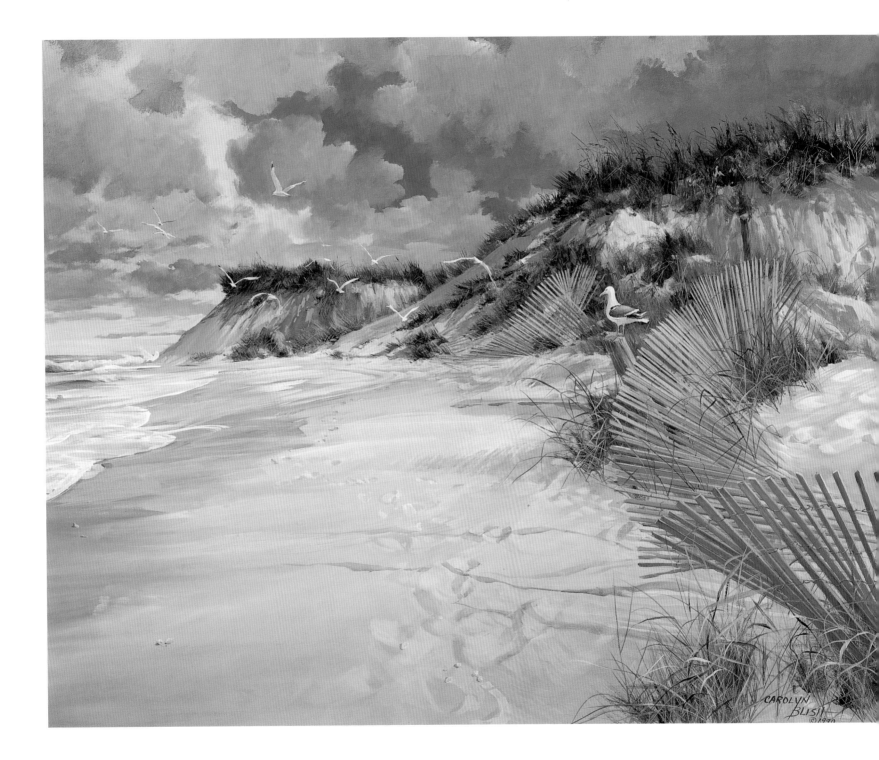

For a long time I was content with my life. There were periods of struggle, moments of discord, but for the most part it was happy and exciting. I was pleased with what I had achieved, proud of being self-sufficient, convinced that, all things considered, I was a pretty good person.

Then I found myself in the valley of shadow. My heart ached for my family; I could do nothing to help. All seemed lost. My heart broke.

Then the greatest miracle that can happen, happened. God intervened at this strategic moment of my need. I became absolutely convinced of his reality. I knew down deep in the basement of my soul that I was no longer adequate. In the depths of my pain and need, I knew what to do. I needed no longer to be alone. I gave the pieces of my broken heart to Christ, and he created a new heart within me. I completely and unequivocally lost my old life and found a new life in him.

• • •

It is God who empowers us to say yes to him, and with that response comes a dynamic conviction that transforms our lives and a trust that grows into absolute certainty.

CAROLYN
BLISH © 1987

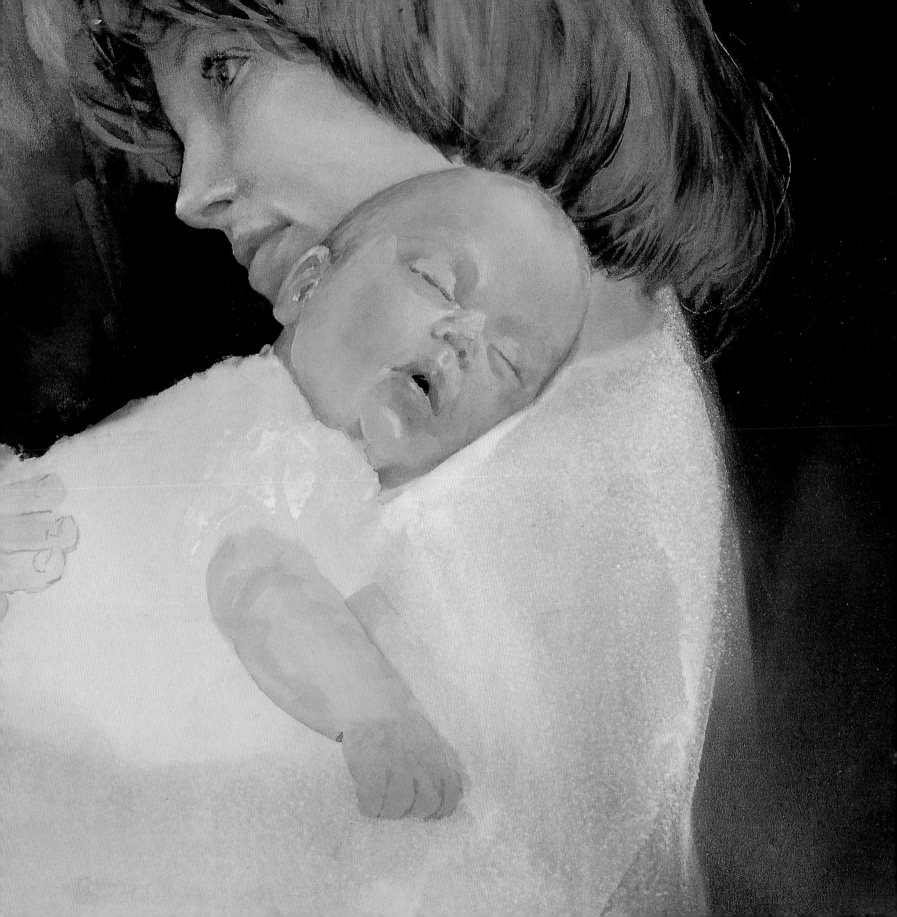

"You will seek me and find me;

when you seek me with all your heart,

I will be found by you, says the Lord…"

JEREMIAH 29:13–14

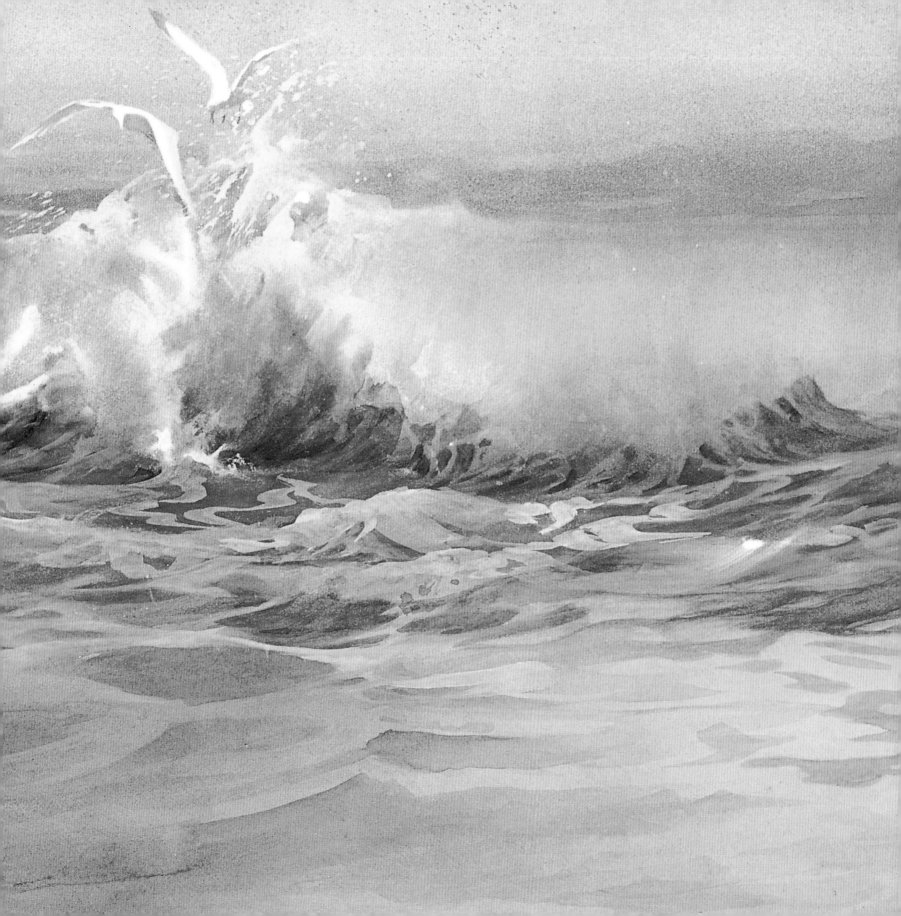

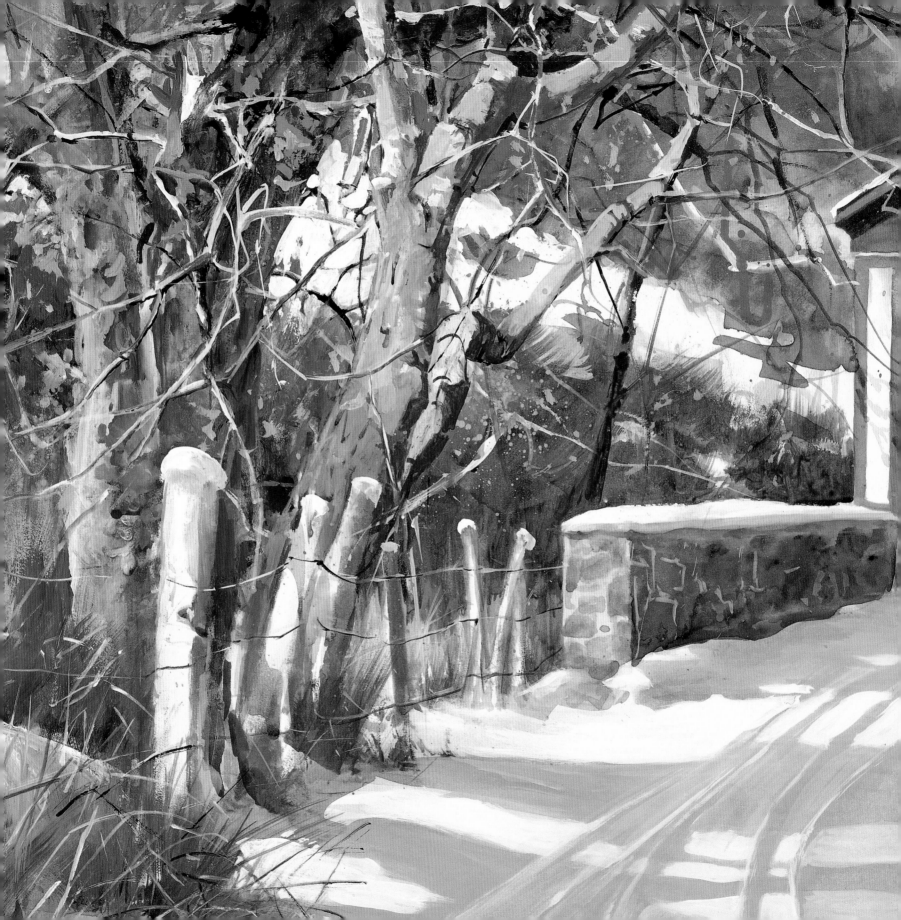

"For you shall go out in joy,
 and be led forth in peace;
the mountains and the hills before you
 shall break forth into singing, and
all the trees of the field shall clap their hands."

ISAIAH 55:12

"...no eye has seen, no ear has heard,
no mind has conceived what God has
prepared for those who love him."

I CORINTHIANS 2:9

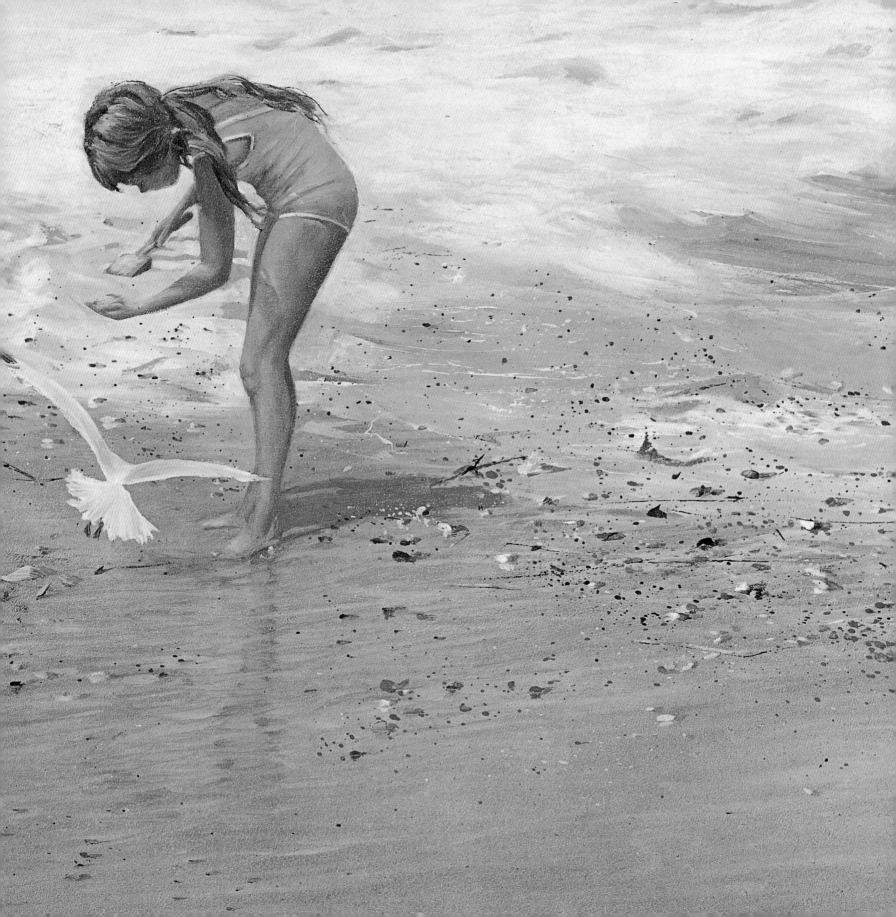

"And when you draw close to God,
God will draw close to you. . . ."

JAMES 4:8

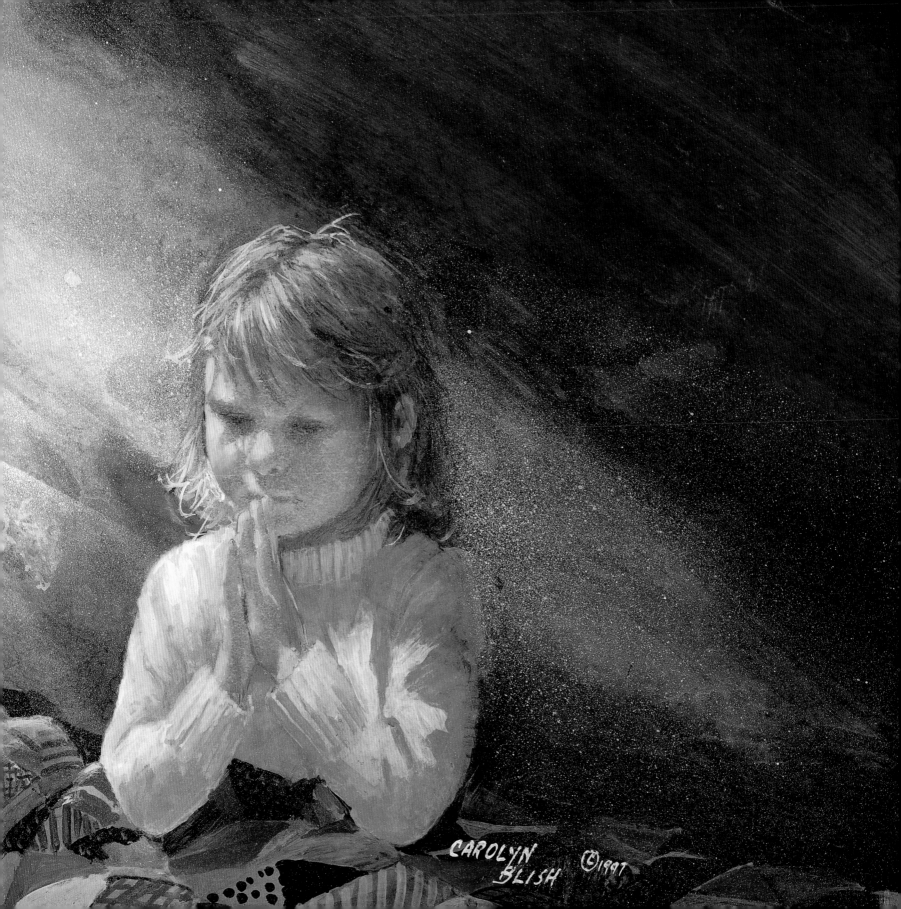

CAROLYN
BLISH ©1997

About the Artist

Through her art, and her written thoughts, Carolyn Blish shares with us a unique wisdom of heart and spirit. Her vision encompasses all of God's creation, from the secret smile of a child and the glorious color of a flower to the sunlit beauty of the shore.

• • •

From childhood, Carolyn knew she would be an artist. She developed her unique style over years of observation and without instruction, painting by "trial and error" for over fifteen years. Then she encountered renowned watercolorist Edgar Whitney, whom she credits with her development of composition and design. Exhibiting nationally since 1965, she has won numerous awards from such prestigious organizations as The National Arts Club, The American Watercolor Society and Allied Artists of America.

Carolyn has enjoyed outstanding popularity as an artist—from her early days as a sketching "cowgirl" on local television to sold-out originals shows. She reached out to a broader audience first in open edition prints,

150

then with fine art limited edition prints from The Greenwich Workshop, Inc. and Mill Pond Press. Inspired by God's creation around her, Carolyn greets each morning with renewed enthusiasm and spends eight to ten hours a day painting. Her favorite subject is children, whose inner essence—wonder, innocence and warmth—shines through in her work. Carolyn has been blessed with a loving and supportive family. Her two daughters and grandchildren are models for many of her works. She describes her husband Stanley as her best friend and most perceptive art critic.

• • •

What does the future hold for Carolyn Blish? With God's grace, she will always paint and see the world as his creation. Her deep personal relationship with the Lord draws her out of her studio and into the world to share her faith with groups large and small. Through her art, writing and speaking, she continues to praise him in line, color and word.

List of Paintings

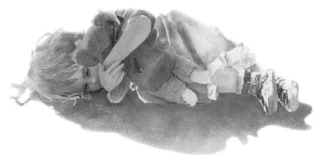